Facing
the Apostle

Paul's Image in Art

Armanda Santos, FSP

Prayers by Germana Santos, FSP

With a Foreword
by Michael Morris, OP

To the Oblate Sisters,

Jesus delights in you.

S. Armanda Santos

Pauline
BOOKS & MEDIA
Boston

Library of Congress Cataloging-in-Publication Data

Santos, Armanda.

Facing the apostle : Paul's image in art / Armanda Santos ; prayers by Germana Santos ; foreword by Michael Morris.

p. cm.

Includes bibliographical references (p. 127).

ISBN 0-8198-2683-9 (pbk.)

1. Paul, the Apostle, Saint—Prayers and devotions. 2. Paul, the Apostle, Saint—Art. I. Santos, Germana. II. Title.

BX2167.P38S26 2009

225.9'2—dc22

2008042262

The Scripture quotations contained herein are from the *New Revised Standard Version Bible: Catholic Edition*, copyright © 1989, 1993, Division of Christian Education of the National Council of the Churches of Christ in the United States of America. Used by permission. All rights reserved.

Texts of the New Testament used in this work are taken from *The New Testament: St. Paul Catholic Edition*, translated by Mark A. Wauck, copyright © 2000 by the Society of St. Paul, Staten Island, New York, and are used by permission. All rights reserved.

Excerpts from Pope John Paul II's "Letter to the Elderly" and the text from *Built of Living Stones* is used with the permission of the Libreria Editrice Vaticana, 00120 Città del Vaticana.

Cover design by Rosana Usselmann

Cover art: *Saints Aemidius and Paul,* from a polyptich. Carlo Crivelli (1435/40–1493). Cattedrale, Ascoli Picenso, Italy. Scala / Art Resource, NY.

Published by Pauline Books & Media, 50 Saint Paul's Avenue, Boston, MA 02130-3491

Printed in the U.S.A.

www.pauline.org

Pauline Books & Media is the publishing house of the Daughters of St. Paul, an international congregation of women religious serving the Church with the communications media.

1 2 3 4 5 6 7 8 9 14 13 12 11 10 09

In memory of my loving father,
Armando Lourenço dos Santos
1922–2001

Contents

List of Illustrations

Foreword

Nothing is so gratifying to a teacher's heart than to see a student respond enthusiastically to the information imparted in class. When Sister Armanda took my courses in Christian Iconography some years ago at the Dominican School of Philosophy and Theology in Berkeley, she perched herself in the front row in order to better view the battery of images that were projected—images of biblical figures, of saints, of signs and symbols that have long been the visual language of Christian consciousness and the splendor of Church art. Her interest in iconography was intensely focused, as if she were taking inventory of some long-hidden treasure. Being much younger than I, she had probably not been inundated with these images as I was in Catholic grammar school. In the past forty years the language of Christian visual culture has not been consistently taught. While instruction in sacred art was mandated by the documents of the Second Vatican Council, it has been rarely offered in schools, in seminaries, or even in Pontifical universities. The consequences have been devastating. Over time this visual language has been forgotten. People see, but they do not fully understand. The art can still attract and fascinate them, but the spiritual tether that linked

the image with the soul has been severed. More often than not, the faithful find it difficult to interpret what they see in their own churches. Where art remains, it beckons to be rediscovered.

In this handsome and well-planned volume, Sister Armanda invites the reader to rediscover and meditate upon the iconography of St. Paul, to follow his life pictorially and reflect upon the scriptural passages, the legends, and the prayers that celebrate this great Apostle from his mystical conversion to his dramatic martyrdom. She has chosen images that range from the classically familiar to the new and innovative. In this delightful mix we can see how Paul's life has been interpreted by artists of every age. But Sister Armanda's book is more than just an historical survey of Pauline imagery. She uses the visual to familiarize the reader with the Apostle's writings. Starting with a quotation from Sacred Scripture, Sister Armanda weaves biography, formal analysis, aesthetics, theology, history, and legend together in her chapters. Then each study is completed with a prayer that raises this wealth of information up to the spiritual plane. This is essential. For what good is Christian art if it does not draw us closer to God? Such art should lead us to prayerful reflection just as photographs of loved ones spark fond memories and associations. Knowledge comes to us through the senses and this physical delight ought to translate into food for the soul.

Sister Armanda has compiled her material and presented it in a way that is accessible to readers of every age and background. In doing so, she has followed the dictates of Saints Peter and Paul. For 1 Peter 5:5 says, "clothe yourselves with humility." Likewise, in Paul's Letter to the Philippians (2:3) it says, "Do nothing out of selfish ambition or vain conceit, but in humility consider others better than yourselves." This is good advice for preachers, teachers, and writers. Sister's text is not in the least bit pedantic. While thoughtful and informative, she never talks

down to her audience. Her prose is as warm and engaging as her personality.

Congratulations to Sister Armanda on work well done, and to her Congregation, the Daughters of St. Paul, for another inspiring religious publication that expresses so beautifully the harmony found between word and image.

MICHAEL MORRIS, OP

Professor of Religion and Arts,
Dominican School of Philosophy and Theology

Acknowledgments

This book has been possible because of the encouragement, support, friendship, and love of many people. I wish to thank my religious community, the Daughters of St. Paul, where I have come to love St. Paul and with whom I await the inheritance of so great a father. I am especially appreciative to the sisters in the community of Redwood City, California, who have always been ready to listen to "one more inspiration." I also want to recognize those Daughters of St. Paul who have consistently sustained my efforts with this project: Sisters Germana Santos, Margaret T. Sato, Domenica Vitello, Madonna T. Ratliff, and Donna W. Giaimo. *I am grateful!*

I am grateful to my family, beginning with my parents, Armando and Marita; to my siblings, Germana, Grace, John, and Maria; and to my niece Sofia and my nephew Armando, for their loving affection, nurturance, festive spirit, and prayers. *I delight in you!*

For my teachers: I am especially indebted to Fr. Michael Morris, OP, whose knowledge and understanding of iconography and its symbolism have motivated me with apostolic creativeness; to Fr. Joseph Boenzi, SDB, for his spiritual wisdom, keen insight, and goodness; to

Fr. Michael Monshau, OP, for his love of the word proclaimed; and to Michael P. Horan, Ph.D., for his pastoral intuition and committed love for the Church. *I am grateful!*

I appreciate my friends and the good people who cheered me on while I was working on this project, and those who make my life beautiful and creative through their kindheartedness, acceptance, and enthusiasm for life: Sr. Karen M. Derr; Thomas W. Lennartz; David J. Nickgorski, OMV; Fr. Paul R.Vassar; Dr. Remo L. Morelli; Lois Mammone; Fr. George Evans; Claire Ciavola; Kim R. Shah; Kathleen Dolan; Elaine Piparo; Kathryn Richards; my Portuguese family; and the supportive and delightful people of California. *I am grateful!*

Introduction

*Arts by their very nature are oriented toward the infinite beauty
of God which they attempt in some way to portray by the work of
human hands; they achieve their purpose of redounding to God's praise
and glory in proportion as they are directed the more exclusively to the
single aim of turning men's minds devoutly toward God.*

CONSTITUTION ON THE SACRED LITURGY, NO. 122

I belong to a religious community of sisters, the Daughters of St.
Paul, who claim St. Paul as our patron and to whom we give the
privileged title of Father. As a Pauline sister, I consider myself an heir
to the treasure of images of the Apostle Paul that artists of every gen-
eration have given to the Church. These images, found in museums,
churches, religious sites around the world, books, and the Internet,
allow us to see in Paul someone larger than life, a giant of faith, a man
who left his imprint on Christianity and who has been immortalized in
paintings, sculptures, and representations of all types.

Through my own reading, study, and prayer, I have discovered that behind the colossal figure of Paul was a man of indomitable strength and determination; someone capable of accessing and articulating truth, yet who was also skilled at adapting his message to various circumstances; someone gifted at forming lasting personal friendships while maintaining a keen ability to network for the sake of the Gospel. This man, who lived in deep intimacy with his God, also experienced moments of testing and loneliness. At times he was all too human. He displayed impatience with the pettiness of others, was prone to conflict, and thrived on argumentation. Yet Paul was also blessed with great sensitivity, especially in his dealings with his disciples and communities.

As I have come to know and love St. Paul over the years, so I greatly desire to extend the same opportunity to others. I hope to offer some insight into the person of Paul by reflecting on his iconographic portrayals. Religious art, through its use of signs and symbolic representation, can be an effective conduit into a world of theological meaning and scriptural revelation.

In this book an image of Paul anchors each chapter and becomes the primary medium for narrating his story. Thus, iconographic images of Paul are the vehicle through which we will explore the life and message of the great communicator, theologian, apostle, and saint. While my intention for this work is not the formal critical analysis that art historians use, I have nonetheless chosen to engage Paul's iconography using a simplified method to approach and critique the art. For some paintings I explore the artist's biographical data and background. For others, I look at the shapes and colors the artist employs and what the use of such may suggest; for still others, I approach the work by looking at it from the perspective of content (i.e., unpacking meaning contained in the work) or the particular response the artwork may evoke in the viewer.

Before proceeding further, it may be helpful to look at some of the terms appearing in this presentation and how they are used:

- The word *icon* usually refers to an image or artistic representation. In addition, within the Eastern Christian tradition an icon is a picture or representation of the sacred, manifesting the divine presence and thus becoming a means to contemplation and theological reflection.

- *Iconography* refers to the pictorial material, including its symbolic and emblematic elements, relating to an image.

- A *portrait* is an image that bears a historical likeness of a person.

- *Attributes* are elements or external characteristics that embody or suggest a particular person or an activity for which the person is known.

Here I want to go beyond the attributes traditionally associated with Paul, the sword and the book, and allow Paul's iconography to reveal something of his personality and inner life: his passion for the Gospel; his indefatigable spirit; his identification with Christ; his humanness, friendships, and love for the Church; his universal outlook, etc.

In presenting an iconographic portrait of the Apostle Paul, the methodology I have followed draws from such primary sources as Paul's undisputed letters. These are the seven letters that biblical scholars recognize as written by the Apostle Paul himself: Romans, 1 and 2 Corinthians, Galatians, Philippians, 1 Thessalonians, and Philemon. Where particular biographical data was lacking, it has been supplemented by the disputed or "deutero-Pauline" letters—i.e., those generally attributed to Paul's disciples, such as Ephesians, Colossians, 2 Thessalonians, 1 and 2 Timothy, and Titus—as well as by the Acts of the Apostles and other ancient writings.

In the Gospel of John we read that certain Greeks approached the disciple Philip with the request: "[W]e want to see Jesus" (Jn 12:21). This desire of Jesus' contemporaries has become the longing for every Christian generation. The quest to "catch a glimpse" of Jesus, Mary, the angels, and the saints with our own eyes has resulted in their images being illustrated, painted, carved, chiseled, woven, embroidered, inked, printed, photographed, and filmed. The attempts, the successes, and the masterpieces of artists of every generation to image the Divine have moved and enthralled us, capturing our imagination.

Christianity has harnessed the potential of visual art to proclaim, transmit, reveal, and communicate the message of Jesus in ways that deeply touch the human heart. These visual images, in whatever form they take, give us possibilities for new associations and ideas to interpret the message of Jesus within contemporary contexts that are ever-more universal and relevant to the times and to the demands of discipleship. Visual images, especially when we speak of religious art, are open doors into an endless world of meaning. In this visual world, an artist employs symbols to create images that articulate meaning, proclaim a message, and unlock revelation.

In the U.S. bishops' document *Built of Living Stones*, Pope Paul VI is quoted as saying that the Church entrusts to art a mediating role

> analogous to Jacob's ladder descending and ascending between the human and the holy: Art is meant to bring the divine to the human world, to the level of the senses; then, from the insight gained through the senses and the stirring of the emotions, raise the human world to God, to his inexpressible kingdom of mystery, beauty and life.[1]

For this reason, when religious art flows from the community's organic, living experience of faith, the beauty of the work is not contained in the design, form, or market value of the image, but in the

signs, meaning, and the religious perspective the work offers to the community as gift. With this insight as a basis for our understanding and appreciation of religious art, we can better undertake the adventure of discovering the great Apostle Paul and his relevance for the Church's journey of faith.

Chapter I

A Heart Transformed

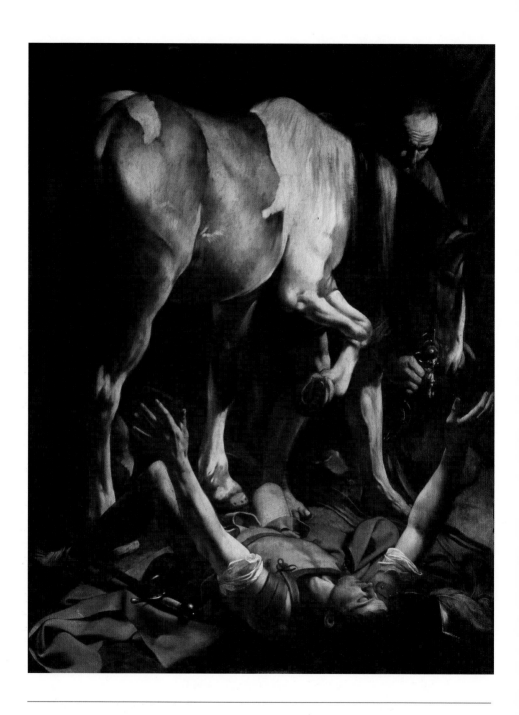

Caravaggio (Michelangelo da Merisi) (1573–1610). *The Conversion of St. Paul* (ca. 1600). Santa Maria del Popolo, Rome, Italy. Photo credit: Scala /Art Resource, NY.

"Saul, Saul, why are you persecuting me?"
"Who are you, Lord?" I said.
And the Lord said, "I am Jesus, whom you are persecuting.
Get up and stand on your feet! This is why I have appeared to you
—to make you my servant and a witness for what you've seen
[of me] and what I'll show you."

ACTS 26:14–17

This famous image of the conversion of Paul was painted in 1600 by Michelangelo Merisi, who was born in Caravaggio, Italy, around 1570. Over time, people commonly referred to the artist as Caravaggio. The painting alludes to a sequence of events not entirely captured by the artist but narrated three times in the Acts of the Apostles (although, interestingly enough, Paul's fall from a horse never actually figures into the accounts). Saul (his Jewish name), a devout young Pharisee, is on his way to the city of Damascus to discipline followers of "the Way," whom he believes are guilty of subverting Jewish Law. While traveling, he experiences something dramatic and unexpected—indeed life changing. Caravaggio's painting suggests a period from before the rider's fall to shortly after it has taken place, all the

while directing our focus to the precise moment of encounter between Saul and "the One" he has been persecuting.

The painting is divided horizontally between the horse in the upper half and Saul in the lower foreground. The composition seems crowded, with the large, imposing horse dominating the scene. The horse's hindquarters and left foreleg, along with its back hump, establish two vertical lines, with the horse's handler forming a third line. Saul lies on the ground with his left leg bent like two sides of a triangle, a shape mirrored from a different angle by the horse's raised leg. The horse's

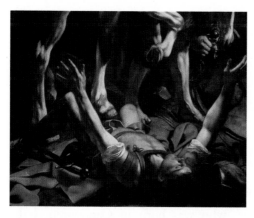

physical strength, conveyed in its muscular legs, is replicated in Saul's muscled arms. The legs of the horse and the assistant, along with Saul's legs and arms, converge in the middle of the painting, creating a visual confusion that compels us to shift our gaze away from it and onto the serene figure lying on the ground. Some apparent crisis has caused this rider to let go of the reigns of his horse, casting the leather straps aside as he relinquishes control of the horse to the attendant.

Caravaggio produces a variety of shapes that direct our reflection toward some revealing aspects of the image. Saul's arms form a half-circle as they strain upward to grasp, to welcome, and to embrace Someone invisible to us but very present to him. A large oval shape highlights the central action in the painting, extending from Saul's right arm, then proceeding up over the horse's head and midsection, and finally reaching back down to Saul's left arm. The other large shape

emerging and dominating the painting is a rectangle formed by the horse's body and framed against a black background. Out of the darkness on the right-hand side of the painting a light descends in parallel rays, illuminating both the horse and the figure lying beneath it. Radiant light, a great metaphor for revelation, floods Saul in strong, warm hues, but its source remains mysterious as it emanates from darkness. Saul's eyes are closed to convey the blindness ascribed to him in the Scripture account, while the horse's penetrating gaze tries to assess its fallen rider. Even with his eyes shut, Saul appears alert and magnetically drawn by something outside himself. His face is warmed by the intense heat of the light, which he later describes thus: "I saw a light from the sky more brilliant than the sun.... And the Lord said, 'I am Jesus, whom you are persecuting'" (Acts 26:13–15). Saul is receptive, offering no visible resistance.

Although, of course, not a Roman soldier, Saul is often mistakenly depicted dressed in military attire. The sword, which lies on his left side, is possibly included simply as part of the Roman uniform; iconographically, however, as we will see, it represents much more than that. Saul's military helmet lies next to his head. His white sleeves are rolled up and his red cape rests carelessly on the ground.

As a photograph captures a moment in time, Caravaggio's work offers a snapshot of a memorable event in Paul's life; it visually articulates the transformation that moved Saul away from power and pride to humility and dependence. This painting represents a dimension not visible to us but that Saul entered and embraced, welcoming "the One" whom he had persecuted but who now becomes his Lord and Savior.

It is interesting to note that Caravaggio actually painted two conversion pictures. In September 1600, the young artist received a commission from Monsignor Tiberio Cerasi, treasurer general to Pope Clement

VIII, for two paintings: *The Crucifixion of St. Peter* and *The Conversion of St. Paul*. Both were to be placed over the altar in the Church of Santa Maria del Popolo in Rome. The artist's first rendition of Paul's conversion was beautiful in its execution and graphic interpretation, but by the time the painting was completed, the architect had changed the dimensions of the altar, and Caravaggio decided to redo the painting. In comparison, the second version is far superior. Something seems to have happened to Caravaggio between the first and second paintings, perhaps a transformation or personal conversion of his own. The first version of the painting is a literal representation of the biblical narrative, with an extremely crowded composition. In the second, the drama takes place on a psychological level and entices us to continue pondering the image. Paul's outstretched arms tell of a complete surrender to his Lord, while the omnipresent God is personified in the horse with its epic size.

Caravaggio's masterpiece hangs at a height that allows the viewer to gaze up at the painting from the perspective of the fallen rider. This is the painter's way of drawing us into the story, permitting us to see the action of God in our own lives from a position of humility. However, for the image of Paul's conversion to best communicate meaning to us and become an example for our own personal transformation, we must interpret it in the light of its biblical context:

> I was on the road at about midday ... when I saw a light more brilliant than the sun shining around me and those who were traveling with me. We all fell to the ground and I heard a voice saying to me in the Hebrew language, "Saul, Saul, why are you persecuting me? It's hard for you to kick against the goad!"
>
> "Who are you, Lord?" I said.
>
> And the Lord said, "I am Jesus, whom you are persecuting. Get up and stand on your feet! This is why I have appeared to you—to make you my servant and a witness for what you've seen [of me] and what I'll show you." (Acts 26:13–17)

Paul's conversion is a significant occurrence in this remarkable life poured out "for the sake of the Gospel." Besides the narratives recorded in Acts, Paul refers in his own writings to this life-changing event. So transformative is the encounter with the risen Jesus that Paul compares it to the act of God in creation: "For the God Who said, 'Out of the dark a light will shine,' has caused His light to shine in our hearts to reveal the knowledge of God's glory in Christ's face" (2 Cor 4:6). God, who created light, also chooses to manifest himself to Paul in light.

Christ "ambushes" Paul on the road to Damascus, and in that moment Paul falls in love. It is a love that expands his heart to include everyone. So great is this experience of conversion that he later says, "I consider everything to be loss for the sake of the surpassing greatness of knowing Christ Jesus my Lord" (Phil 3:8).

Scripture, as mentioned earlier, does not directly refer to Paul as falling off a horse. Most artists, however, have used this image metaphorically to explain the radical change in Paul's life. Why might this be so? The horse is an animal representing strength and power. Then, too, the image of Paul being "unseated" has come to symbolize surrender of one's own control in favor of trusting dependence on God. Paul's goal may have been to bring down the Christians, but as often happens in good stories, there is a surprise twist that has Paul's world turned upside down.

So life changing is Paul's encounter with Jesus that he can nevermore turn his gaze away from Christ. He later attests that he saw the risen Lord in the same way the other apostles saw him (see 1 Cor 15:8); this reality stands at the center of Paul's life and theology and confers authority on his apostleship. The Damascus event gave Paul vision for his future mission among the Gentiles; the light bestowed gave clarity to his teaching. Neither the vision nor the light ever dimmed.

We who daily set out in pursuit of Christ would do well to remind ourselves that Jesus longs for our encounter with him even more than we do. This encounter with Christ must flourish into a relationship that will transform us, just as it did Paul.

Prayer

Light and darkness,
sight and blindness,
power and weakness,
control and surrender.

The Damascus event in Paul's life is played out
 often in my own life,
though in a less dramatic way.
Lord Jesus, I meet you in so many ways,
sometimes in silence and prayer,
or by stumbling to the ground of my existence.

As I journey through the days of my life,
stop me, call out my name,
send me your dazzling light,
take hold of me, as you took hold of Paul.
Even when I kick against the goad,
even when I lack courage,
even when the fatigue of life overtakes me,
even when I fall again,
even when I lose my way,
even in all these things,
I trust that you are with me,
and that your grace is sufficient for me.

Like Paul, let me know how to be companioned by others,
led by those around me who can point out the way,
because the journey is very lonely without them.

Chapter II

Apostle of the Gentiles

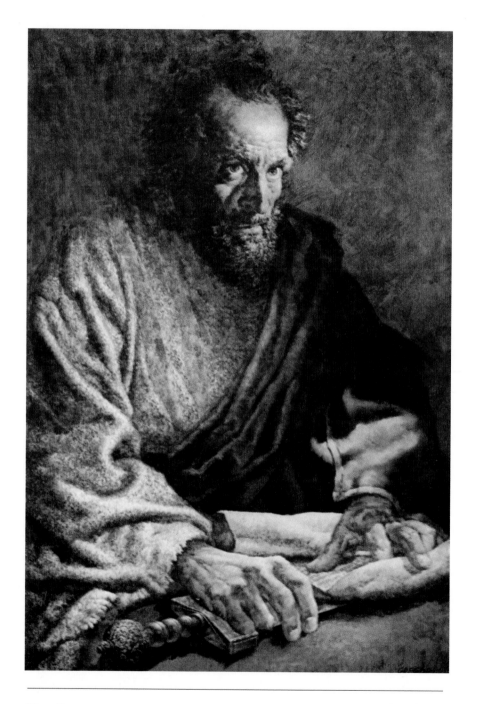

Nino Gregori. *Paul the Apostle* (twentieth century). Private collection. Courtesy of the Daughters of St. Paul, Slough, United Kingdom. © Daughters of St. Paul.

*[F]or the One Who worked through Peter
for the apostleship of the circumcision
also worked through me for the Gentiles ...*

<div align="right">

GALATIANS 2:8

</div>

This formal portrait of the Apostle was done by twentieth-century Italian artist Nino Gregori, born in Trieste, Italy. Gregori, who gave this painting of St. Paul as a gift to the Daughters of St. Paul in Langley, England, confessed that it had required much reflection, and even caused him anguish, given the extraordinary personality of the Apostle.

Paul sits behind a table, which permits us to see him only from the waist up. A sword and a partially open parchment are the only items on the table, and his strong hands rest heavily on them as if guarding or protecting something precious. He wears a green tunic with red stripes, over which is draped a blue cloak with orange trim; both garments reflect a style consistent with clothing of first-century Palestine. The edges of his sleeves, seen above his right hand, are frayed.

The Apostle's face appears stern; he almost seems to be frowning, as if he has been disturbed or interrupted in what he was doing. The

painting shows evidence that Paul has been reading and not writing, for text already appears on the parchment and he holds no writing implement. Has Paul received unsettling news from one of the churches? Is he pondering his response? Indeed, his forward posture signals his readiness to act. This dramatic image of Paul—complete with piercing eyes, long nose, furrowed brow, receding black and gray hair, and bearded face—invites us to apply to him the following words of Scripture: "He crouches down, he stretches out like a lion ... who dares rouse him up?" (Gen 49:9).

A light, dimly illuminating the entire work, shines brightly on Paul's forehead. The word of God illumines his mind and calls him

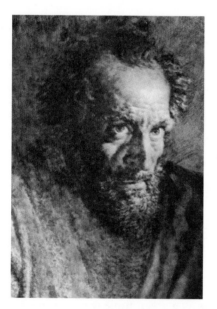

forth to be a herald, not of his own ideas and opinions but as a voice for the living God. Gregori has depicted Paul in full pastoral activity, in the attitude of listening to inspiration, as he holds his parchments, which for him are instruments of evangelization. The artist, like others before him, has sought to reproduce not only Paul's physical features but also the fire and spirit that motivated him.

What did Paul actually look like? We find in the *The Acts of Paul and Thecla*, a second-century document by an unknown author, the only extant physical description of the Apostle: "At length they saw a man coming, of small stature with meeting eyebrows, bald or shaved head, bow-legged, strongly built, hollow-eyed, with a strong, crooked nose."[2]

Images of Paul differ greatly depending on the artists, their particular insights into Paul, the degree of their fondness or admiration for him, and their artistic style. It may be argued that in Paul's case, artists have often applied stereotypical features of the philosopher—i.e., a long beard and baldness—to indicate the Apostle's knowledge and standing as a "lover of Wisdom" in the Person of Christ. However, the fact that certain characteristics depicted of Paul and Peter (including the latter's short, curly hair and beard) have remained consistent from earliest times suggests that such features may be based on the saints' actual physical appearance.

In terms of the attributes by which Paul is recognized, the sword is principal, since it was by decapitation that Paul suffered martyrdom. Both Paul's Letter to the Ephesians and the Letter to the Hebrews also refer to the sword emblematically, speaking of the Word of God as "*the sword of the Spirit*" (Eph 6:17) and as a "two-edged sword" piercing "between soul and spirit" so "it can discern the innermost thoughts and intentions of the heart" (Heb 4:12). Along with the sword, Paul often holds a book or scroll of parchment representing the word he proclaimed and the letters he wrote to the churches. The Apostle's letters make up the bulk of the New Testament and constitute the first written commentary on the life of Jesus. "… [T]he good news I proclaimed is not a human gospel, for I didn't receive it from a man nor was I taught it—I received it through a revelation of Jesus Christ" (Gal 1:11–12).

Who was this Apostle sent to proclaim the Good News to the Gentiles? If we want to know Paul we must look primarily at the letters he wrote, which give firsthand information about his person and teaching. Although we find more concrete details about Paul's life in the Acts of the Apostles—attributed to Luke, whose earlier volume is the Gospel named for him—Pauline scholars have reservations as to its

complete historical reliability. Today the most accepted approach to understanding Paul is to refer to his undisputed letters as a primary source, while using the Acts for supplemental information when it does not contradict Paul's own words. According to contemporary Pauline studies, Acts is an especially dependable source for understanding the development of first-century Christianity, but caution is needed in harmonizing certain events recorded in Acts with the letters of Paul. Having stated this, the following is one possible chronology of Paul's life according to present-day biblical scholarship, as presented by Michael J. Gorman in his book *Apostle of the Crucified Lord*.[3] The dates given are approximate ranges.

A.D. 5–10 Saul is born in Tarsus and is first educated there and then in Jerusalem.

A.D. 30–36 Saul persecutes the Church (1 Cor 15:19; Gal 1:13–14; Phil 3:6; Acts 8:1–3; 9:1–2).

A.D. 33–36 Saul encounters Jesus on the road to Damascus and receives his mandate as apostle to the Gentiles (Gal 1:15–16; Acts 9:22, 26; Phil 3:3–11). His name is changed to Paul.

A.D. 33–39 Paul spends three years in the desert of Arabia and then moves back to Damascus (Gal 1:17).

A.D. 36–39 Paul makes his first visit to Jerusalem since his conversion, spending two weeks there with Cephas and James (Gal 1:18–19).

A.D. 37–48 Paul begins his missionary work in Syria and Cilicia, possibly venturing out to other places as well (Gal 1:21; cf. Acts 9:30).

A.D. 46–58 Paul continues his efforts for the Gospel in Asia Minor, Greece, and elsewhere, and begins writing letters.

Paul participates in the Council of Jerusalem (Gal 2:1–10).

Paul makes his home in Corinth for eighteen months (Acts 18).

Paul stays in Ephesus for two to three years, possibly spending some time in prison (Acts 19).

A.D. 54–58 Paul is arrested in Jerusalem (Acts 21:27–36).

A.D. 60–63 Paul is imprisoned in Rome (Acts 28).

A.D. 62–68 Paul is possibly released from Roman imprisonment and returns to mission work and letter writing.

A.D. 62–68 Paul is martyred under the Emperor Nero.

The Apostle Paul's mission to the Gentiles involves preaching that Jesus, the crucified Christ, had been raised from the dead and that reconciliation with God comes about through Christ and not by the power of the Law. This becomes Paul's Gospel, his Good News received by revelation from Christ, confirmed by the Church, and proclaimed by Paul, who declares himself its servant (cf. the Letter to the Galatians). Paul comes to view the Law as having only the function of regulating daily life, not as the source of life and definitely not something that should be mandated for the Gentiles. For Paul, justification comes not through circumcision or strict adherence to the Law, nor through slavery to religious practices; faith in Christ alone brings salvation.

The Gentile community delights in this Good News and accepts the Gospel Paul preaches. The church in Galatia is especially grateful,

but as it happens, some "troublemakers" worm their way into Galatian territory, taking advantage of Paul's absence and discrediting his teaching. These false teachers insist that the Gentiles need to be fully incorporated into Judaism—which meant, among other things, submitting to circumcision—before becoming Christians.

Paul's Letter to the Galatians is his response to these agitators who taught an alternative gospel to Paul's unchanging message. "I'm amazed that you're so quick to desert the One Who called you by the grace of Christ and are turning to a different gospel" (Gal 1:6), the Apostle declares, hoping to shake the Galatians into stark reality. Paul's anger with them is not surprising. He sees them discarding the very freedom Christ secured for them by his death and resurrection. Paul is justified in his discouragement; he has toiled to liberate these Gentile converts from their slavery to the Law, offering them the freedom of the Lord Jesus, yet now they seem to be slipping back into slavery (cf. Gal 4:8–9). He chides them: "Who has cast a spell over you? Before your eyes Jesus Christ was publicly portrayed as crucified!" (Gal 3:1). And he even laments: "I'm afraid that all my work for you may somehow have been in vain" (Gal 4:11).

Writing much later to the Christian community in Rome, Paul presents Abraham as a man whom God declared righteous before there ever was a Law to be followed and obeyed. If Abraham was pleasing to God because of his faith, Paul argues, why do non-Jews have to follow the Law so as to receive righteousness? The Law came with Moses, who lived centuries after Abraham. Paul states his case thus: "*Abraham's faith was credited to him as righteousness....* For the promise to Abraham and his descendants that they would inherit the world was based not on Abraham's observance of the Torah but on the fact that he had been restored to fellowship with God through faith" (Rom 4:9, 13).

Paul's fundamental teaching rests on this theme of salvation through Jesus Christ. It is the "Christ-event" that has brought humankind reconciliation, justification, salvation, and freedom. This is the Good News, offered first to Jews and now made available to Gentiles, and to each of us, and Paul is its herald.

Prayer

Paul,
apostle and servant of Jesus Christ,
you spent yourself tirelessly to bring the Good News
 to the Gentiles.
Your preaching, exhortations and letters
were meant to form and inform the early Christians,
nourishing them in their beginning faith.

Throughout the centuries
your message continues to be a deep well of fresh,
 bubbly water
from which people can drink freely and quench their
 spiritual thirst.

You offered to the early Church and to us
that true freedom that comes,
not from human regulations and laws,
but from adherence to Christ Jesus.

But like the "foolish Galatians," sometimes we, too,
resort back to the slavery of pride, appearances, power,
the slavery of personal sin and social sin....

Help us to overcome any imprisoning chains,
that "distort the good news of Christ" (Gal 1:7).
May we discover daily the true freedom
 that only he can give.

Through God's grace, and your prayers,
let us "walk according to the Spirit" (Gal 5:16)
and become bearers of good news
within the surroundings of our daily existence.
Amen.

Chapter III

Good News
to Write About

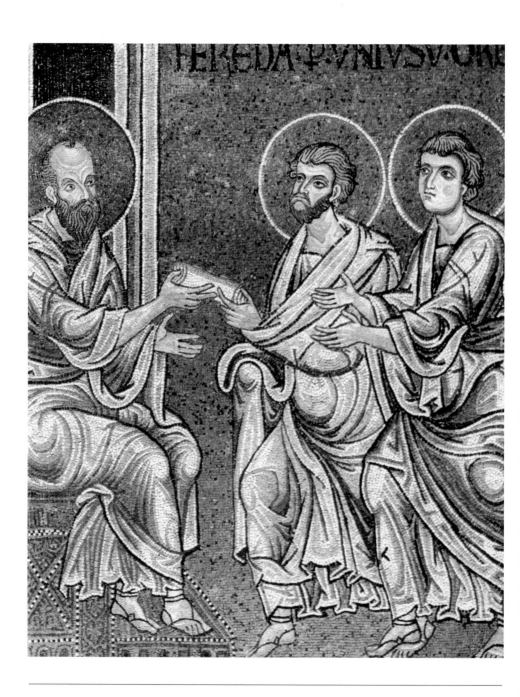

Artist unknown. *St. Paul with Timothy and Silas* (twelfth- or thirteenth-century mosaic). Courtesy of Duomo di Monreale, Palermo, Italy.

This greeting is written with my own hand—Paul's.
This is my sign in every letter, this is how I write.

2 Thessalonians 3:17

An icon is a receptacle for content; in looking at an image, we do not simply see an object but we also associate some meaning to it. For example, in the mosaic *St. Paul with Timothy and Silas*, we see Paul sitting on a throne-like chair. Because being seated in a chair traditionally denotes authority, we immediately associate this image with Paul's teaching authority.

In this mosaic the unknown artist, whose work dates from between the twelfth and thirteenth centuries, has employed a technique common in Eastern iconography to express Paul's knowledge and wisdom —that is, portraying his forehead as high, broad, and furrowed. While the Apostle is in the process of handing a papyrus scroll to his disciple Silas, the second disciple in the image, Timothy—distinguished by his youthful, beardless face—stretches out his hand in the gesture of receiving. Here the artist is recalling for us the letters Paul wrote to the Christian communities and their importance for the Church. Paul him-

self insists that what he writes is truly the word of God, for he knows the mind of Christ (cf. 1 Cor 2:16). The Pauline letters, among the earliest writings of the New Testament, remain relevant for our times, for the word they proclaim addresses universal themes with which Christians today can identify.

The New Testament attributes thirteen letters to Paul, seven of which, as indicated earlier, scholars consider to be of undisputed authorship because they reflect a similar theology, perspective, and vocabulary. The other six differ from the undisputed letters on certain eschatological aspects, writing styles, and theologies that reflect a later Church with a more developed structure.

Paul's letters appear in the biblical canon not in the order in which they were written but in order of their length, beginning with Romans, the longest letter, and ending with Philemon, the shortest. One way to study St. Paul is to read the letters in chronological order, from the earliest written to the latest. One possible chronological arrangement of the letters is: 1 Thessalonians (A.D. 49–51), Galatians (52–54.), 1 and 2 Corinthians (52–54, 55), Romans (54–55.), Philippians (58–60), and Philemon (58–60), followed by the deutero-Pauline letters: 2 Thessalonians, Colossians, Ephesians, 2 Timothy, 1 Timothy, and Titus.

It is important to remember that both the Acts of the Apostles and the deutero-Pauline letters continue to have great value for the insight they provide into the Apostle's person and mission. Whether or not written by Paul, the letters of disputed authorship reflect his influence and show the development of his teaching. These writings, individually and taken as a whole, enrich our understanding and appreciation of the Apostle Paul.

How did Paul go about the task of writing his letters to the Christian churches? In New Testament times much of the writing was

done on papyrus, from a plant native to the swamps of Egypt. The leaves of this plant were laboriously processed into paper. A writing instrument would be fashioned from a piece of cane sharpened to a point and partly split at the tip. This reed, when dipped in ink, became a pen, the conventional tool for writing in Paul's time.

Professional secretaries were in demand in antiquity; correspondence was generally entrusted to scribes, who functioned as an extension of the sender in their capacity as writers, editors, record keepers, and stenographers. Paul would have followed this arrangement when writing his letters. Although dictated, they were still his letters in every way, for he was the author whose thoughts, reflections, and teachings were being transcribed.

The most direct proof that Paul used dictation is found in the Letter to the Romans, where the presence of a secretary is indicated in the conclusion of the letter: "Tertius, the writer of this letter, greets you in the Lord" (Rom 16:22). While this is the only time a letter writer is named, the role of scribes who took dictation or edited the letters is alluded to in other places:

"This greeting is written with my own hand—Paul's. This is my sign in every letter, this is how I write" (2 Thes 3:17).

"Look how large the letters are that I'm writing to you with my own hand!" (Gal 6:11).

"This greeting is my own writing—Paul's" (1 Cor 16:21).

In each of these instances, the insistence of certain words of greeting written in Paul's "own hand" implies that the rest of the text was written by the hand of another—namely, a secretary.

Paul was certainly capable of writing his own correspondence, but apart from the fact that first-century norms prescribed the use of professional scribes, Paul, with his quick, clever, and creative mind, would

have benefited greatly from a secretary who could keep pace with the Apostle as he brilliantly expounded his message. Some of the Pauline letters also mention co-senders who perhaps, along with Paul, contributed to the content. Such examples are noticed in the letters to the Thessalonians, Corinthians and Philippians:

"Paul, an apostle of Christ Jesus by the will of God, and Timothy our brother to the church of God in Corinth ..." (2 Cor 1:1).

"Paul, Silvanus, and Timothy to the church of the Thessalonians ..." (1 and 2 Thes 1:1).

"Paul, called by the will of God to be an apostle of Christ Jesus, and our brother Sosthenes, to the church of God in Corinth ..." (1 Cor 1:1).

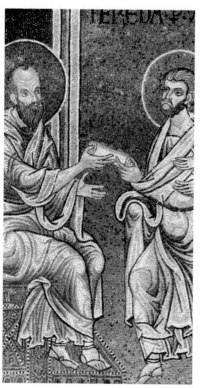

Paul's style of writing is intimate and personally revealing; these letters emanate from the heart of one who is sharing with beloved brothers and sisters what he has experienced, lived, heard, seen, and felt. The letters are encouraging and pastoral in content, alternately urging, exhorting, responding to hearsay, correcting, advising, and comforting.

After having established or helped to lay the foundation for the various Christian churches, Paul has yet another opportunity to proclaim through his writings the gospel of God's faithful love.

Structured in a format common to his time, the letters open with a greeting and thanksgiving, continue with the main message, and culminate in final salutations and concluding remarks. These pastoral messages were meant to be read aloud in the local assemblies that gathered together on the Lord's Day. The public reading ensured that all the Christians in the area were present to hear words addressed to the whole community.

Paul wrote letters to speak for him in his absence. Always focused on his children's formation in the faith, he takes every opportunity for "building up of the body of Christ" (Eph 4:12). He goes so far as to declare: "*You* are our letter, written on our hearts, for all to know and read. Yes, you're clearly a letter from Christ delivered by us, written not with ink but with the Spirit of the living God, not on stone tablets but on tablets of human hearts" (2 Cor 3:2–3).

Because Paul sometimes writes in direct response to queries previously posed to him, and we only have his answers without the questions themselves, it may sometimes seem as if we are reading one-sided conversations. The consequence of Paul's letters not being heard in their full context may result in the reader's misunderstanding or a harsh judgment for certain comments Paul makes. We may even want to agree with the author of 2 Peter when he writes: "… [O]ur beloved brother Paul wrote to you with the wisdom he has been given…. There are some things in his letters which are difficult to understand …" (2 Pet 3:15, 16). Yet by committing time and other resources to the great adventure of reading and studying Paul's writings, availing ourselves of the abundant commentaries available on every aspect of his work, we will better understand Paul's heart and, through that prism, welcome his words and teaching for the richness they contain.

Prayer

Lord God,
as St. Paul poured out his heart to the world
through his letters,
may his writings find a home in me.

Send your Holy Spirit to guide me
in the great adventure of reading and studying Paul's writings
so that I may:

> savor the depth of truth contained in them,
> grow in knowledge and in the freedom of the children
> of God,
> understand the passages that are complex,
> be moved, inspired, and comforted,
> and be conformed to the image of Christ.
> Amen.

Chapter IV

Paul's Parental Role

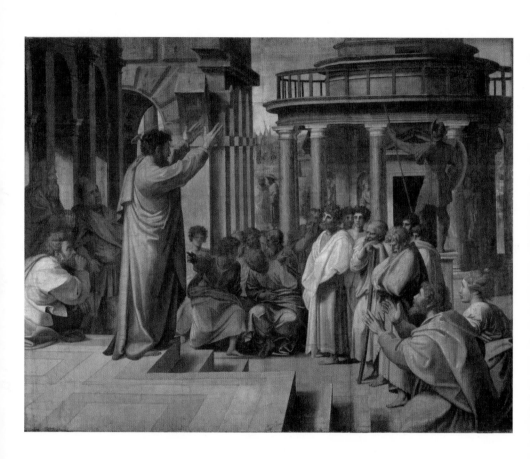

Raphael (Raffaello Sanzio). *Paul Preaching at Athens* (1515–16). Bodycolor on paper mounted onto canvas (tapestry cartoon). Victoria & Albert Museum, London, Great Britain. Photo credit: V&A Images, London / Art Resource, NY.

Such was our affection for you that we were prepared to share with you
not only God's good news but even our very selves, so dear had
you become to us ... [Y]ou also know how, like a father with his own
children, we exhorted you, encouraged you, and urged you to conduct
yourselves in a manner worthy of God....

1 THESSALONIANS 2:8, 10–12

The work *St. Paul Preaching at Athens* belongs to Raphael Sanzio (1483–1520), an artist usually known by his first name alone. This painting, done around 1515, may at first seem like an odd choice when discussing Paul's parental role. After all, the Apostle's mission at Athens (cf. Acts 17:16–34) met with indifference on the part of most of his hearers. How could a mission ending in apparent failure give us any insight into Paul as father, nurturer, guide?

It is my contention that this work of Raphael shows Paul at his parental best, patiently engaging in the process of religious formation. Like a concerned father or mother, Paul tries to meet these "children" on their own level, adapting his message in a way they will best understand while encouraging them in a journey toward acceptance of and maturation in Christ.

In the painting we see Raphael's interpretation of Paul speaking at the Areopagus, a place of philosophical debate in Athens. Paul stands fearlessly, for his goal is to preach the Gospel. To those who hear and accept, new life is assured in Christ Jesus. Surrounded by solid columns of Roman architecture, which allude to the power and permanence of the empire and its ideologies, Paul proclaims something new: "[A]nyone who's in Christ is a new creation ..." (2 Cor 5:17). The Apostle's uncompromising zeal and passion for the Gospel are reflected in his posture.

Although the source of light in this painting comes from behind Paul, illuminating his back, he casts no shadow on the crowd; Paul does not block the light but serves as a "light for the Gentiles" (cf. Isa 49:6, Acts 26:17–18).

Paul stands at the very edge of the step with both arms raised high in entreaty. His earnestness conveys his fatherly affection and concern. We can almost hear him repeat the words he had earlier addressed to the Corinthians, "For though you may have innumerable guides in Christ, you don't have numerous fathers—*I* was the one who begot you in Christ Jesus through the good news" (1 Cor 4:15).

The crowd appears to be attending to Paul and is engaged in what he is saying. In this painting Raphael has captured a mixture of reac-

tions among the audience. Various expressions reflect attitudes of listening, pondering, skepticism, combativeness, discernment, and acceptance—characteristic responses in any formative encounter.

Paul's raised arms are mirrored by one of his listeners at the bottom right of the painting. Paul is in the act of imparting wisdom by communicating Christ; the other man is in the act of receiving the word preached. To this man's right are two other men, one with folded arms and one leaning with both hands on a walking stick. Both gestures suggest they are settling in for a long rhetorical debate. In contrast to those in the group who stand, assenting in faith to Paul's preaching, the skeptics sit and feign shock, engaging in dramatics and seemingly trying to disrupt Paul's preaching. Paul is not disturbed by this behavior; he realizes how challenging his words might be to some people.

Every parent must be prepared to deal with a child's rebellious response. Paul is compassionate enough to understand the people's initial rejection. His love will not allow him to give up on these "children." Also noteworthy in this scene is the statue of the Roman soldier with its back to Paul, a particular body language used by Raphael to indicate how the authorities have turned their backs on Paul's message.

At various times in his letters Paul calls the Christians "my children," and yet some may find it hard to visualize Paul as a parent lovingly doting over a child. Images of God inscribing us in the palm of his hand,[4] of our being his delight as we play in his presence,[5] or of our being the apple of God's eye[6] are easier to imagine, but it is challenging to envision Paul through similar parental language. "… [W]e were gentle with you, like a nursing mother comforting her child" (1 Thes 2:7). This tender image of Paul stands in seeming contrast to other images we may have conjured both from his writings and from centuries of iconographic, stern-looking portraits.

Yet Paul relates to his Christian converts as a concerned and loving parent. Nowhere in his writings is this seen more than with the Christian community at Galatia. Writing to them, Paul declares emphatically, "It's no longer I who live, it's Christ who lives in me!" (Gal 2:20). His identification with Christ thrusts the great Apostle Paul into his apostolic work with the goal of molding all who hear the Gospel into the pattern of Christ, that is, "until Christ takes form in you" (Gal 4:19). The nature of the formative process calls on Paul's parental resources as he seeks to identify himself to his spiritual children as both mother and father, displaying love and responsibility similar to that of parents who guide the development, formation, and education of their offspring into mature adults.

Like a mother angered by those who threaten her children or an infuriated bear robbed of her cubs (cf. Hos 13:8), Paul verbally attacks those who intimidate his beloved Galatians, to whom he has given life. It is within this context—of antagonism caused by agitators who have undermined Paul's authority, and of his additional disappointment with the Galatians for believing the "false teachers" over him—that Paul writes: "My children, once again I'm suffering birth pains until Christ takes form in you" (Gal 4:19). These Christians are no longer faceless believers but have become Paul's children. "[Y]ou don't have numerous fathers—I was the one who begot you in Christ Jesus through the good news" (1 Cor 4:15). In giving "life," Paul begets the believer just as a mother and father beget their children and assume the responsibility to nourish and form them. Hence, Paul cares deeply for the Galatians, even though he suspects that the Christian community does not yet fully understand his investment in their spiritual birthing and development.

There are two thoughts to consider in Paul's declaration: "My children, once again I'm suffering birth pains until Christ takes form in

you" (Gal 4:19). The first is that Paul's parental language, claiming the Galatians as his dear children, conveys his willingness to suffer again and again for them. The second gives voice to the purpose for which he is willing to suffer, namely, until Christ is formed in them—that is, when they can genuinely declare with Paul that they are alive in Christ Jesus (cf. Gal 2:20). This is Paul's apostolic project: to give life through his preaching, to nourish his spiritual children through his visits and letters, and to invest everything of himself, including suffering for his children's behalf as they develop into full maturity in Christ.

The use of maternal and paternal metaphors is not unique to Paul. He was keenly aware that in the Hebraic tradition parental images were used to personify God. Biblical metaphors provide us with effective and limitless meaning because we are able to better comprehend a reality when we compare it to one with which we are already familiar.

Paul proclaims Jesus with the persuasive powers of the Jewish mother depicted in 2 Maccabees, who "Filled with a noble spirit ... reinforced her woman's reasoning with a man's courage" (2 Macc 7:21), and who exhorted each of her sons to be fearless in the face of persecution and martyrdom. From the deep well of maternal instinct, Paul protects his spiritual children. He is tender and compassionate with their erring ways, and with tears he nurtures them back to the clear vision of Jesus Christ, who was crucified "before your eyes" (cf. Gal 3:1). Paul also instructs, disciplines, motivates, and guides, exhorting his children to imitate Paul's own spiritual lifestyle in its continual movement from death to life.

Every parent, dutifully attending not only to the physical and moral formation of one's offspring but their social, academic, and spiritual education as well, may at times have been disappointed by a child's choices. Paul too experienced this; for example, it appears that he had reached an

impasse with his beloved Galatians. What can Paul do or say to bring them back into the freedom of Christ? Paul's aim for the Church in Galatia is striking: Paul wants nothing short of Christ taking form in them (cf. Gal 4:19). But how is formation toward christification[7] to come about? In his writings Paul offers his children and disciples of today a blueprint for how to arrive at union with and maturity in Christ. To be formed into Christ, it is not enough simply to follow the moral law or to fulfill an exhortation for virtuous living. For Paul, what is important is a Christian's full incorporation into Christ:

"For in Christ Jesus ... what matters is faith working through love" (Gal 5:6).

"Thus there's no condemnation now for those who are in Christ Jesus" (Rom 8:1).

"But if Christ is in you, even though your body is dead because of sin, then your spirit is alive because of righteousness" (Rom 8:10).

"When I was a child I spoke like a child, thought like a child, reasoned like a child. When I became a man, I put an end to childish ways" (1 Cor 13:11).

"But whatever I had gained ... I have come to consider it loss for the sake of Christ.... For his sake I've cast everything aside and regard it as so much rubbish so that I'll gain Christ and be found in him ..." (Phil 3:7–9).

Reaching the full stature of Christ—that is, spiritual maturity— means being open to the Spirit of God who works in each person, leading him or her through a progressive and integral journey of growth. This is what Paul desired for his spiritual children and still desires for his heirs today.

Prayer

Holy Apostle Paul,
you lived for the goal
of forming Christ in your followers.
You yourself declared that you were a "form"
 or model to imitate.

If I live and love the way you did,
I can be sure of reaching your intensity of life in Christ.
In you I find an example to follow,
a teacher to inspire me,
a protector to rely on,
a loving parent who suffers birth pangs
to bring me to new life.

You identified with Jesus, the Divine Master,
to the point that your thoughts were the thoughts of Christ,
your words and actions mirrored those of Christ,
your heart became the heart of Christ.

The journey of christification is lifelong.
Pray for me as I walk the same path
of conforming my mind, my heart, my very life
to Christ Jesus my Lord,
to the point that I let him "completely embrace
 and conquer me."[8]
Amen.

Chapter V

A Traveler for the Gospel

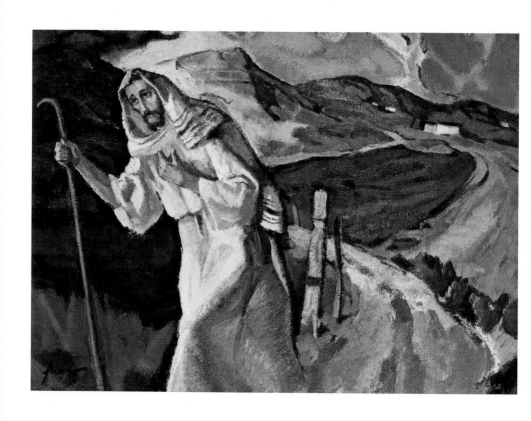

Rossano Veneto Venzo. *Paolo, Luce di Cristo* (1977). Courtesy of Vatican Museums, Cittá del Vaticano, Italy.

I continually mention you in my prayers and ask that somehow by
God's will I'll finally manage to come to you, for I long to see you and
to share with you some spiritual gift in order to strengthen you,
that is, so we may be mutually encouraged by one another's faith....

<div align="right">ROMANS 1:9–12</div>

A large painting (measuring almost four feet by three feet), *Luce di Cristo* (Light of Christ), is located in the contemporary art section of the Vatican Museum. Completed in 1977, it is the work of an Italian Jesuit brother, Rossano Veneto Venzo (1900–1989). *Fratel* (or Brother) Venzo, as he was known, rarely painted human figures because of his preference for nature scenes with vibrant colors. Every Venzo painting is an eruption, a celebration of colors, and *Luce di Cristo* is no exception, with its pulsating oranges, blues, browns, and greens. Against such a vivid backdrop and dressed in his white tunic, Paul seems to shout out, "I am the light of Christ!"

A mountainous ridge and rough terrain dominate this painting, dwarfing the few houses along Paul's route. In the foreground, Paul walks with deliberate step, his body forming the painting's main vertical line. The walking staff in his right hand parallels Paul's leaning

torso. His slanting frame, together with the poles along the road, which descend in height, give the viewer the sense of a steep incline. A long road snakes around the fields, blanketed with warm golden colors and rich, dark soil. The painting invites us to explore the world beyond this image and consider all the terrains and conditions of Paul's journeys by land or sea.

The painting appears to have two sources of light. One descends from above, illuminating the mountains and giving the fields their warm autumn hues and the sky its azure adornment. A second brilliant light goes before Paul to lead and illuminate his way, while it pulls or compels him forward. As Paul progresses along his journey, the space he leaves behind is limitless, probably like the vista lying ahead, which only he can see. This impression of depth and therefore distance gives us a glimpse of how far Paul traveled and of the distances between the towns and cities of Asia Minor. The artist was obviously aware of the topology of the rocky mountain terrain Paul traversed, including the arduous climb through the Taurus Mountains, the great chain near Tarsus with the highest peaks reaching beyond 10,000 feet. The mountain range blocks us from exploring the left side of the image, but we can imagine that just beyond our vision stand fields ready for harvest. Venzo's long, strong brush strokes give the fields a sense of movement; we can almost discern a rustle or gentle sway in the tall grass.

Paul, dressed in a thin article of clothing, may possibly be suffering the cold mountain air. His white tunic is symbolic of his purity of life and the transparency of his intentions in spreading the Gospel. Paul's left hand rests over his heart as if grasping to himself something cherished. At the same time the position of his hand draws our eyes up to his face, which is circumscribed by a cloth mantle that accentuates his grave and somber expression. Paul's eyes are slightly raised, allowing him to

see the road ahead but reinforc-
ing for the viewer the curvature
of Paul's back, weighed down by
his concerns.

In this painting the Apostle
appears to be journeying alone,
although at that time it was cus-
tomary to travel in groups for
reasons of safety. The artist may
have intended this aloneness to
emphasize the moral weight of
Paul's responsibility for the
churches. The walking stick that he wields to secure his step on the
rough terrain is more like a shepherd's staff. In Christian iconography
it serves as a symbol for the office of a bishop, whose responsibility is to
tend, guide, protect, and lead God's people after the manner of Jesus,
who identified himself as the Good Shepherd.

The cities Paul visits on his travels are large, thriving centers of
commerce with sizable populations. In them, ancient myths, history,
and culture have built up over time. Cities are connected by a vast sys-
tem of roads and waterways that allow for trade but also serve as con-
duits for the exchange of ideas and information. This is especially true
of cities with ports and shipping routes that brought speed to travel for
a world already demanding connectedness. Antioch, for example, built
near the Mediterranean coast in what is today southeastern Turkey, was
such a city. Thessalonica, in Greece, was also a major port city, while
Corinth is strategically located on an isthmus that connects the north-
ern and southern portions of Greece, with the Adriatic Sea on one side
and the Aegean Sea on the other.

Established as it was in the ancient world, travel had many setbacks. It does not take much imagination to understand how hazardous Paul's long journeys were. The dangers he encountered by sea are well recorded by Paul: "[T]hree times I was shipwrecked—a day and a night I spent out on the deep!" (2 Cor 11:25). Because waterways depended on good weather for navigation, ships did not sail during the inclement winter months.

Travelers by road also faced perils, as Paul dramatically describes:

> In my many journeys I've been in danger from rivers, from robbers, from my own race, from Gentiles; I've been in danger in the city and in the wild, on the sea and from false brothers. I've toiled and been through hardships, spent many sleepless nights, been hungry and thirsty; I've often gone without food, been cold and without sufficient clothing. (2 Cor 11:26–27)

When Paul speaks of having experienced sleepless nights, hunger, and thirst, we can assume that at times he found himself far from human habitation, with no other alternative than to spend his nights exposed to the cold, deprived of even basic human necessities like food and drink.

The Acts of the Apostles chronicles Paul's journeys, dividing them into three apostolic trips and a final journey to Rome while under arrest to stand trial before Caesar. The first journey is narrated in chapters 13 and 14 of Acts; the second is found in Acts 15:36–18:22; and the third is recounted in Acts 18:23–21:16. Paul's final trip to Rome takes place in Acts 21:15–28:31. However, no general consensus exists among Pauline scholars on whether the apostolic journeys actually followed the itinerary found in Acts. In his letters Paul never refers to his journeys as an organized plan of action, nor does he itemize his various travels. Nevertheless, according to Pauline scholars, the framework of the trips as described in Acts does serve as background information for studying

the far-reaching extent of Paul's influence. The Apostle gives us no hint regarding the time it took to travel from city to city. From Acts we can approximate how long he stayed in certain places but not the timetable for the long miles in between. We who travel today in speed and comfort may fail to recognize Paul's commitment of time and personal abnegation in traveling by foot from place to place.

What drove Paul onward in his journeys despite fatigue and the hardships of travel? It was his conviction that the Gospel was of divine origin, as he told the Galatians: "… the good news I proclaimed is not a human gospel, for I didn't receive it from a man nor was I taught it— I received it through a revelation of Jesus Christ" (Gal 1:11–12). And so he was driven by an inner urgency to share, to yell out, to tell others the Good News.

In Paul's time the road system and waterways became the means by which the message of Jesus reached far and wide. In our day, the means of communicating with one another have evolved beyond our full comprehension in terms of their speed, quantity, impact, and potential. What would Paul do if he lived today? Without a doubt his travels would take him along the information superhighway, and he would make use of every means of communication possible to preach Jesus Christ. New marvels of communication can be harnessed to multiply the Church's apostolic efforts; all that remains is a commitment to the mandate of Jesus: "Go therefore, and make disciples of all nations …" (Mt 28:19).

Prayer

Paul,
traveler for the Gospel,
proclaimer of the Good News,

you asked your contemporaries to pray for you,
"that the word of the Lord may spread quickly and be glorified"
 (2 Thes 3:1).

Today, God's word travels most swiftly through the media.
Living in the era of global communication,
we recognize these marvelous means of information,
 entertainment, and connectivity
with their potential for all that is good and beautiful,
and for the opposite.

Pray for the creators of the media,
and the consumers of the media,
that those who shape the messages offered through the media,
and those who receive those messages
may believe in the commonality of human dignity,
in the civility of human communication,
in respect and mutual acceptance.
In this way, both the message and the medium
can be channels for what is good, true, and beautiful.

Pray also for those who, like you, seek to proclaim God's word
in this new "place" of evangelization.
Through the blaring and relentless messages of the media,
may we be attuned to your voice coming through these means,
that tiny whispering sound (cf. 1 Kings 19:12),
which is often the way that you speak to us.
And when we hear the soft voice of God's Word,
may we be filled with the grace and peace from
God our Father and Jesus Christ our Lord.

"[W]hatever is true, whatever is honorable, whatever is just,
whatever is pure, whatever is pleasing, whatever is gracious, if
there is any excellence or anything praiseworthy, think of these
things" (Phil 4:8).

Chapter VI

The Mysticism of Paul

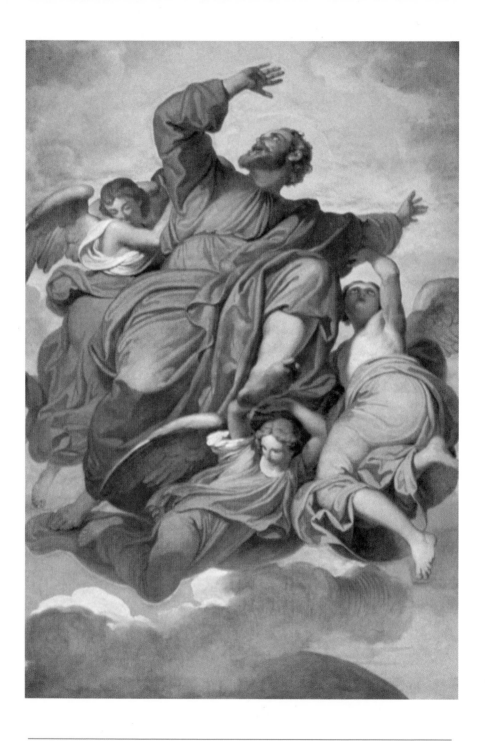

Francesco Coghetti. *Paul, Taken Up to Heaven* (1857). Nave fresco, Basilica of St. Paul Outside the Wall, Cittá del Vaticano, Italy. Courtesy of Basilica of St. Paul Outside the Wall.

So all of us who gaze with uncovered faces at the glory of the Lord
are being transformed into his image, from one level of glory
to the next, and this comes from the Lord, who is the Spirit.

2 CORINTHIANS 3:18

The fresco *Paul, Taken Up to Heaven* visualizes what Paul attempts to explain about an extraordinary mystical experience. The fresco is in the Basilica of St. Paul Outside the Walls in Rome, where the Apostle's tomb is located. This work of Francesco Coghetti (1802–1875), is among thirty-six frescoes chronicling the life of the great Apostle. Twenty-two artists were commissioned by Pope Pius IX to paint these frescoes in 1857 for the new basilica. The previous basilica, destroyed by fire on the night of July 15, 1823, had been adorned with mosaic images of the life of Paul created by Pietro Cavallini (ca. 1250–1330).

In the foreground of Coghetti's striking fresco, cumulus clouds allude to the heavens, and an angel, whose clothing serves as a vehicle, transports Paul upward while the Apostle is supported on either side by two other angels. Paul's body is massive in scale compared to the figures of the angels; his arms and legs seem to be everywhere, looking a bit

awkward and chaotic. He has suddenly been lifted up by the Divine. His body is thrown back by an invisible force that simultaneously pushes and pulls him toward a presence outside the dimensions of the painting, but which is personified by the brilliant aura lighting up the sky. Paul's eyes are transfixed by an attractive presence that leaves him in awe, while his mouth opens spontaneously in exhilaration.

Writing to the Philippians, Paul declares that he has been grasped by Christ (cf. Phil 3:12), as if Christ had physically captured him by surprise. It is this "assault" that Coghetti seems to be alluding to in his fresco. Paul appears to have been literally plucked out of his surroundings to see and hear things he cannot comprehend intellectually but that influenced his life.

The Apostle shares with the Corinthian church his mystical experience by speaking in the third person: "I know a man in Christ who fourteen years ago was caught up to the Third Heaven—whether in the body or out of the body I don't know, God knows. And I know that this man ... was caught up in Paradise where he heard things too sacred to put into words, things which no man may utter" (2 Cor 12:2–4). Because Paul is vague, it is difficult to assess what really happened to him; however, this ambiguity is a component of the divine experience.

What or whom does Paul see or hear? In presenting the events of his conversion, and the mystical narration of his experience with the

divine in the heavens, artists typically communicate the revelation through the use of brilliant light. The response of the person receiving the revelation is usually depicted as astonishment or fear followed by silence. This is equally true in biblical narratives of celestial manifestations (cf. Lk 24:1–5; Mk 16:5–6; Mt 17:2–8). This painting further reveals another connection between Paul's vision on the road to Damascus and the experience of being elevated to heaven. In the former event Paul is "brought down," thrown to the ground, a humbling occurrence that leaves him unable to see for several days. It is a revelatory moment that Paul is later able to recount with great clarity and detail. Then we have the marvel of Paul being "taken up," "caught up to the third heaven," which he is unable to give voice to or ever fully explain. In fact, he mentions the mystical experience only once to the Corinthian Christians (cf. 2 Cor 12:3–4). There is a difference between the two experiences: the Damascus encounter with the Divine is for the sake of Paul's mission and therefore for the good of the community, the Church. Of this Paul speaks openly and often. The second revelatory encounter with the Divine is for Paul himself, a personal gift from a gratuitous God. And because it is such, Paul never gives details of the event, perhaps content to keep it private. Certainly it must have been a tremendous consolation and personal encouragement for his life and mission.

According to saints who have been similarly gifted, in a mystical encounter one's senses and faculties, such as memory, are completely absorbed in God, so much so that external realities become trivial and non-consequential.

St. Teresa of Avila, another great mystic, clarifies for us Paul's experience with her own: She writes about the consolation, the sweetness, and the delight of prayer.

... The soul becomes conscious that it is fainting almost complete-
ly away, in a kind of swoon, with exceeding great and sweet delight.

The soul that has experienced this prayer and this union is left
with a very great tenderness, of such a kind that it would gladly
become consumed, not with pain but tears of joy.

... At this stage it would want to be all tongues so as to praise
the Lord.[9]

As Paul explains, the life of the Spirit that animated Christ ani-
mates us, making us children of God: "God has sent the Spirit of His
Son into our hearts, to cry, 'Abba, Father!'" (Gal 4:6). Thus, all that we
do and are springs from the inner reality: "we're God's children. And if
we're children, then we're also heirs—heirs of God, co-heirs with
Christ, if we suffer with him so as to be glorified with him as well"
(Rom 8:16–17). Far from being a static reality, this life of God, through
Christ, in the Spirit, pulses and grows within us.

As we grow in this life and in intimacy with Christ, it becomes a
union in which two hearts beat as one. Our desires are Christ's desires,
and his will is our will. Paul bends his knees in prayer to the Father,
praying that this relationship will be realized in his followers:

May Christ dwell in your hearts through faith, firmly rooted and
established in love, so that with all the saints you may be able to
understand the breadth, the length, the height, and the depth, and
know Christ's love which surpasses all knowledge so that you may
be filled with all God's fullness. (Eph 3:17–19)

This is what we long for, but how do we reach this union, and how
do we live it every day? How do we integrate what we desire with the
concreteness of daily life with its many choices? The masters of the
spiritual life speak of growth in terms of stages, or movements, to reach
this intimacy.

Blessed James Alberione concretized this spiritual journey in rela-
tion to the Trinity. In the first movement, the heavenly *Father* presents

Jesus to us. At this stage we come to know Jesus, desiring to be like him. We gaze upon Jesus the Master and are drawn into him with an attraction that is at once inviting and engaging. Confronting our life with God's Word, we question ourselves: "Whom or what do you seek, my heart?" Or as Paul would say:

> If you've been raised with Christ, seek the things that are above, where Christ is … think about the things that are above … for you've died and your life is hidden with Christ in God … [A]s God's chosen ones, holy and beloved, clothe yourselves with true compassion, kindness, humility, gentleness, patience…. Whatever you do, whether in word or deed, do it all in the name of Jesus Christ the Lord, and give thanks to God the Father through him. (Col 3:1–3, 12, 17)

In the second movement, *knowledge* of *Christ* gives way to seeing ourselves and everything else with the eyes of our heart, recognizing that Jesus is our *only* Master. Other infatuations and fascinations must disappear, because our choice is for Christ. At this stage, we find all our joy, our happiness, our delightful "taste" only in Jesus.

"… [C]onsider everything to be loss for the sake of the surpassing greatness of knowing Christ Jesus my Lord" (Phil 3:8).

Nothing "… will be able to separate us from God's love in Christ Jesus our Lord" (Rom 8:39).

"… I forget what's behind me and reach out for what's in front of me. I strain toward the goal to win the prize—of God's heavenward call in Christ Jesus" (Phil 3:13–14).

The third and final stage represents ultimate union with God; it means being able to say with St. Paul, "I am alive, but it's Christ living in me," or, to put in another way, "For me to live is Christ" (cf. Gal 2:20) At this stage, no personal effort is involved on our part. We allow the Spirit to work until Jesus is formed in us. It is the *Spirit* who brings this about.

The stages toward mystical union with God or christification are not meant to be a gauge to measure ourselves or preoccupy us with how we are progressing in the spiritual life. Real union with God is transformative, and the only true measurement is fruitfulness. Thus the encounter with Christ is liberating; it empowers us with the resources for living and with a capacity to grow and change in creative transformation.

The process of christification will effect a lasting change so that our thoughts, words, actions, desires, needs, and wants will be Christ's. All of us are called to draw close to God through prayer, even without expecting extraordinary mystical experiences. We are asked only to respond to the daily invitations to discipleship, which come to us in abundance. Holiness lies in accepting God's self-gift, however that comes.

Paul's identification with Christ and declarations of being "*in* Christ" and "*with* Christ" are identifying marks of a mystic. Although Mary of Bethany, John the Baptist, and John the Apostle are contenders for the title, it may still be possible to declare Paul the first Christian mystic.

Prayer

Divine Trinity,
Father, Son, and Holy Spirit,
living and breathing in me,
teach me to pray,
and lead me to the mysticism of everyday life.

As God's child,
I call out in hope and praise:
"Abba, Father!" (Rom 8:15).
"O the depth and richness of your wisdom and knowledge!

How unfathomable are your judgments,
how inscrutable your ways!" (cf. Rom 11:33).

Jesus Christ, my Lord,
I will "seek the things that are above,
where Christ is seated at God's right hand....
for you've died and your life is hidden with Christ in God"
 (Col 3:1–2).
"Whatever you do, whether in word or deed,
do it all in the name of Jesus the Lord, and give thanks
 to God the Father" (Col 3:17).

Holy Spirit of God,
"help me in my weakness,
for I don't know how to pray as I should";
You, Holy Spirit, "plead for me with inexpressible groanings,
and the One who is able to see what's in the heart
knows what you wish
because you intercede for me" (cf. Rom 8:26–27).

Holy Trinity, I offer you all that I am and all that I have
so that I may be a docile vessel of your love.
May "the grace of the Lord Jesus Christ,
the love of God,
and the fellowship of the Holy Spirit be with me!"
 (cf. 2 Cor 13:13).

Chapter VII

Concern for the Churches

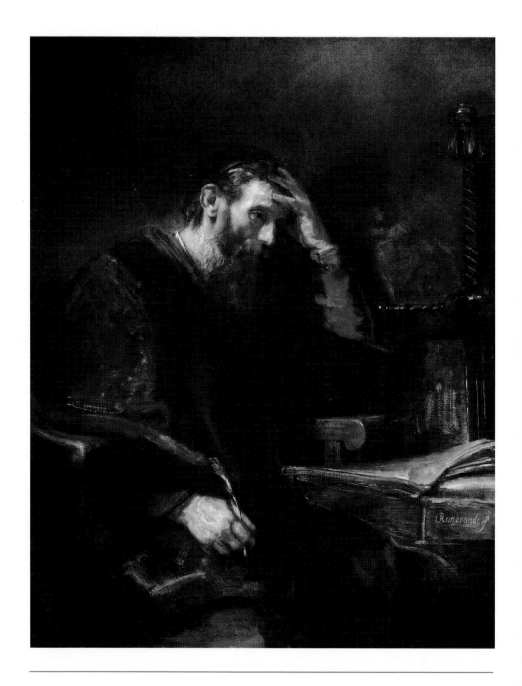

Rembrandt van Rijn. *The Apostle Paul* (ca. 1657), oil on canvas, Widener Collection. Image courtesy of the Board of Trustees, National Gallery of Art, Washington, D.C.

Apart from these external things, I experience daily cares
and anxiety for all the churches. If anyone is weak, I too am weak!
If anyone is led into sin, I too am ablaze with indignation!

2 Corinthians 11:28–29

The painting for this chapter's reflection, *The Apostle Paul*, is one of at least five images that the Dutch artist Rembrandt van Rijn (1606–1669) rendered of the Apostle. Rembrandt's other works on Paul include *St. Paul in Prison* (1627) (which we will look at in Chapter IX of this book), *An Elderly Man as the Apostle Paul* (1659), *Paul at His Desk* (1629 or 1630), *Self-portrait as the Apostle Paul* (1661), and *Two Old Men Disputing* (1628), with the two men commonly identified as Saints Peter and Paul.

An attribute common to all of Rembrandt's paintings of Paul is old age. As depicted in this painting, the Apostle is an elderly man, devoid of virile strength and grace. He is a lonely figure sitting in darkness, weighed down by layers of warm clothing. Rembrandt seems to have left nothing in writing to explain why the Apostle was a favorite subject of his, or why he chose to present Paul as older and vulnerable.

In this 1657 painting, Paul sits in front of a wooden table, filling the space and affording only a partial view of his torso. This gives us the sensation of being in proximity to him. He wears a dark, blanket-like cloak over a red tunic, which is visible only on his arm and neck. Paul also wears an inner white garment and, on his head, a Jewish yarmulke.

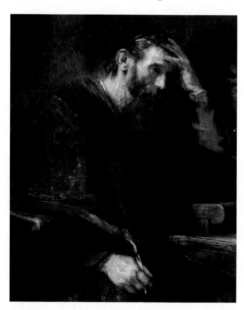

Leaning against the wall, and dominating the right side of the painting, is a sword proportionally larger than normal. This immediately reminds us of Paul's martyrdom by decapitation; it also provides a visual split in the painting, with a certain tension building between Paul and the sword. Is this the tension to which Rembrandt may be visually referring: "I'm torn between the two alternatives—I wish to depart and be with Christ, for that is far better, but for your sake it's more necessary to remain in the flesh" (Phil 1:23–25)? On the table parchments are laid out. Paul seems to be taking a break from them, yet he still loosely holds a writing reed in his right hand. There is no direct source of light; only Paul's face and right hand are illuminated, possibly indicating that they are the repository of God's inspiration.

As we look more closely, we feel as if we are intruding into Paul's sacred space, without his being aware that we are observing him. His venerable and attractive face is that of an approachable person, yet we refrain from disturbing him. Paul's eyes are focused on one spot, but he

appears to be looking beyond the confines of the four walls. Is he remembering someone or something dear? Or is he perhaps trying to discern just the right word to convey a teaching? His other hand rests lightly against his head, a pose related to thinking or pondering.

The darkness shrouding Paul does not allow us to see whether he is in prison or in a comfortable room. This contributes to a sense of mystery hovering over the scene, a mystery which is due not to our inability to know the man, the apostle, the saint, but rather to the depths still left to discover and love about him. Paul's letters reveal an apostle who cared deeply for those he "had begotten" by his preaching of the Gospel. He agonizes over possibly hurting people with his words, cares about their physical and moral health, wants them to do well so that he may be proud of them, and above all wants them to live "in Christ."

Among the sufferings he speaks of in his letters, Paul mentions his concern for the churches he has founded (cf. 2 Cor 11:28–29). When his credibility as an apostle is challenged, it causes him grief. His other anxieties include the way the Galatians behave toward him:

> [Y]ou know that it was due to an illness of the flesh that I first proclaimed the good news to you, and although my condition was a trial for you, you didn't despise or disdain me; instead, you received me like ... Jesus Christ. What has become of your blessed joy? ... Have I become your enemy, then, by telling you the truth? (Gal 4:13–17)

The monetary collection for the Church in Jerusalem (see Rom 15:26–26 and 1 Cor 16:1ff.) also preoccupies him. Paul offers solicitude for the poor as evidence that his gospel—as his ministry—is genuine! "Their one concern [that of James, Cephas, and John] was that we should remember the poor, which was the very thing we were eager to do" (Gal 2:10). Paul has also heard of the sufferings of the church in Philippi, and he encourages the Christians there: "For God has gra-

ciously allowed you not only to believe in Christ but also to suffer for him. You're engaged in the same struggle which you saw me engaged in, and now hear that I'm still engaged in" (Phil 1:29–30).

Is Paul's anxiety over what may happen to his "beloved children" excessive or somehow evidence of the Apostle's weak faith? On the contrary, the anxiety to which Paul refers stems from affectionate concern rather than from a lack of faith in the graciousness of God's protection. When Paul takes leave of the church in Miletus, he says: "And now I commend you to God and to His word of grace ..." (Acts 20:32). Paul cares not only for the churches he founded but also for the individuals who make up these communities, especially those he considers coworkers in the Lord. The following are a few of the persons we read about:

- The slave Onesimus, whom Paul fondly calls "my child" and on whose behalf he appeals to Philemon, Onesimus's master (cf. Philem 1:10);

- Timothy, Paul's young disciple who receives the following counsel about his health: "Stop drinking only water—take a little wine to aid your digestion and because of your frequent illnesses" (1 Tim 5:23);

- Phoebe, one of the many women mentioned in Paul's writings, whom he recommends to the church in Rome, asking that she be received well: "Receive her in the Lord in a manner worthy of the saints and help her with anything she may need from you, for she has been a benefactor to many people, including myself" (Rom 16:2);

- Prisca, Aquila, and "beloved Epaenetus," Mary and Persis, whom Paul remembers with gratitude for all they have done: "They have saved my life ... and have worked so hard" (cf. Rom 16:3–7, 12).

Paul also has his critics, those who do not hold back from complaining about him. Some people accuse him of using fiery words when he is absent and of not having the courage to confront them in person (cf. 2 Cor 10:1–2). N. T. Wright, commenting on Paul's Letter to the Galatians, surmises that when Paul uses more tender language it is not because he lacks courage. Rather, it is as if he

> stops talking theology, breaks off his train of thought, and speaks in quite a different way to his surprised hearers, requiring his hearers (not to mention his readers 2,000 years later!) to follow it closely and think hard. Now, quite suddenly … he tells them what he's thinking, how it feels, what sort of thoughts are rushing through his head at a more personal level. This is a heart-to-heart moment. Almost every line is an appeal to friendship, to family loyalty, to a mutual bond established by their common experience of what God has done for them together….[10]

In a similarly heartfelt way, Paul writes to the Christians at Philippi, thanking them for the gifts they sent during his imprisonment. Their generosity is disarming, and Paul opens his heart to them, sharing some of his concerns. He tells them of his detractors: "Those who proclaim Christ out of jealousy do so insincerely in the hope of causing me trouble while I'm in prison" (Phil 1:17). For Christians, mandated by Jesus to love one another, Paul gives powerful witness to the cause of "fraternal charity," for he cares enough to intervene for the good of a brother or sister (cf. 1 Cor 5, 6, 10; 2 Cor 8). However, Paul's deep concern for his flock does not rob him of his serenity in the face of conflicts, disappointments, accusations, misunderstandings, and external demands. In fact, his sensitivity leads him to prayer on the Christians' behalf:

"May God, the source of hope, fill you with all joy and peace through your belief in Him, so that you'll overflow with hope by the power of Holy Spirit" (Rom 15:13).

"My prayer is that your love will increase more and more with knowledge and every manner of insight so that you'll be able to discover what's best and may be pure and blameless for the Day of Christ, filled with the fruit of the righteousness that comes through Jesus Christ, to the glory and praise of God" (Phil 1:9–11).

"May God fill you with the knowledge of His will through wisdom and all manner of spiritual understanding, that you may conduct yourselves in a manner worthy of the Lord and fully pleasing to him ..." (Col 1:9–10).

"I beg you ... by our Lord Jesus Christ and the love of the Spirit, to join me in my struggle by praying to God for me that I may be delivered from the unbelievers in Judea and that my service in Jerusalem may be acceptable to the saints ..." (Rom 15:30–31).

Paul shows us how to handle our daily anxieties and concerns. Ultimately his hope in the resurrection enables him to find strength and courage despite the most pressing preoccupations. He relies completely and in every situation on Christ: "I am able to do everything through the One Who strengthens me" (Phil 4:13).

Prayer

Live anew, Paul, with your knowledge, your spirit, your zeal,
 your fervor and holiness.
Live and enlighten the minds that are darkened.
Live and sustain in their struggle the devoted apostles
 of our times.
Live and bring your elevations and your contemplations!
Live as you lived in St. Mark.
Live as you lived in St. Titus.
Live as you lived in St. Timothy.
Live as you lived in St. Luke.
Live as you lived in St. Thecla.[11]

Chapter VIII

The Prisoner

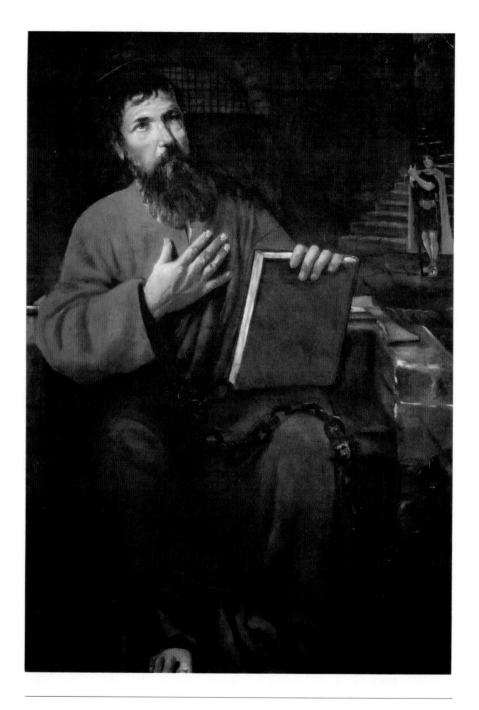

Eugenio Roccali. *Paul in Chains* (1947). Private collection of the Daughters of St. Paul, Boston, MA. © Daughters of St. Paul. Photo: Mary Emmanuel Alves, FSP.

This painting was not done by a Caravaggio or a Rembrandt. In fact, it is far from being a masterpiece according to artistic sensibilities and technique. However, it conveys a sense of empathy toward and esteem for its subject. As the following story indicates, the amateur artist had reason to admire and take encouragement from St. Paul in chains.

For a period during World War II, the Daughters of St. Paul in Staten Island, New York, each Sunday hosted at their convent approximately forty to 120 Italian prisoners of war. The men would attend Sunday Mass and then stay for a spaghetti dinner cooked by these sisters. Eugenio Roccali, the artist who painted *St. Paul in Chains*, was one of the young prisoners of war. In 1947, after the war had ended, Roccali presented this painting as a gift to the Pauline community in gratitude for those special Sundays. His choice to portray Paul as a prisoner must have stemmed from Roccali's own experience during this difficult time

away from his homeland. He would naturally have identified with the constraints imposed on Paul during his internment, as well as with the

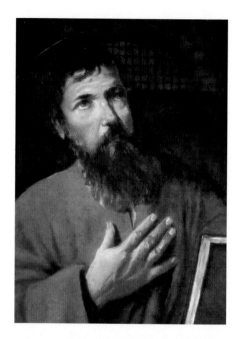

pangs of longing and loneliness caused by separation from loved ones. The painting continues to be treasured by members of the community, not only for the thoughtfulness of the gift or its historical significance, but also for the iconographic value it holds for every Daughter of St. Paul who, like her father Paul, has been chosen to "bring the charity of Truth."[12]

Looking at the painting, we see Paul as the dominant figure taking up most of the space on the canvas. Giving diminutive importance to the prison guard, the artist compels us to focus our gaze on the prisoner. This visual perspective puts Paul "in your face," presenting him as a person of interest who demands one's full attention.

The Apostle sits on a stone structure that resembles a throne or *cathedra*, the bishop's chair placed in the cathedral of a diocese as a sign of the bishop's teaching office. The chair conveys Paul's authority as an apostle of the word. Here he is teaching the faithful not with his verbal eloquence, since he is in prison, but with his letters, represented by the heavy book he holds. These letters give the written word a freedom— "the word of God cannot be chained"—that the writer himself is denied: "I'm suffering and in chains like a criminal ..." (2 Tim 2:9).

Paul's face exhibits signs of fatigue, yet his eyes gleam in the conviction that his sufferings "... don't compare with the glory to come, which will be revealed to us" (Rom 8:18). "... [W]e keep our eyes on what is unseen rather than on what can be seen, for what can be seen is transitory but what is unseen is eternal" (2 Cor 4:18). Paul's hands are large—the strong, gifted hands of a craftsman, the tent maker that he was. One hand is placed over his heart, indicating it as the living source of his words and the place from which he takes his teaching.

The darkness and dampness of the stone prison is juxtaposed against Paul's warm radiance. His red garb symbolizes his imminent martyrdom, which is further emphasized by the sword that lies across the back of his throne. A mantle completes Paul's attire, its green color representing Paul's rich spiritual life and his hope in eternal life.

In various passages Paul identifies himself as a prisoner, but how many times was he actually incarcerated? According to secondary sources, namely the Acts of the Apostles and the Second Letter to Timothy, Paul may have been imprisoned as many as five times, each imprisonment varying in duration. The following are among the references:

"After administering a severe beating to them they threw them into prison ..." (Acts 16:23).

"Then the tribune came up, arrested Paul, and ordered that he be bound with two chains ..." (Acts 21:33).

The governor "... ordered him to be held in Herod's praetorium ..." (Acts 23:35) "Two years later Porcius Festus succeeded Felix. Since Felix wished to gain the favor of the Jews, he left Paul in prison" (Acts 24:27).

"And when we came to Rome, Paul was allowed to stay by himself, with the soldier who guarded him" (Acts 28:16).

"... [M]y life is already being poured out like a libation—the time of my departure is imminent" (2 Tim 4:6).

Among Paul's internments, two in particular merit closer examination. First, the Apostle composes his letter to the community at Philippi from prison, the location of which is not known with certainty. This letter, as we have already seen, is one of Paul's most affectionate. He opens it by expressing his love for the Philippians: "It's right that I should feel this way about you because I have you in my heart, and because you all share my grace, both in my imprisonment and in the defense and confirmation of the good news" (Phil 1:7). In spite of his sufferings, Paul rejoices. He can be jubilant first because his imprisonment has … "actually had the effect of advancing the Gospel" (Phil 1:12); instead of his confinement being a setback, his chains have given others "the confidence to proclaim the word even more fearlessly" (Phil 1:14). Paul is constrained, but the Gospel is free—for the Word of God cannot be bound. Paul's second motive for rejoicing is precisely that he is "in chains" for Christ and everyone knows it, permitting this witness to further advance the cause of the Gospel.

The other imprisonment to consider is the one that begins in Caesarea (Acts 23:35; 24:27) and continues with Paul en route to Rome. After having been in prison for two years, Paul is finally sent to Rome to stand trial. There follows the arduous journey by sea with the shipwreck in Malta, the survival of which would have been a stressful experience for anyone, but much more so for Paul. He is older and therefore more frail than his companions, especially after having spent two years in jail. Nonetheless, the situation at Malta bears blessings for Paul in the numerous converts that result from his preaching the Gospel (cf. Acts 28:1–10). Leaving there, being under arrest, Paul continues on his way to Rome. Before he can rest, there is still the long journey to make along the *Via Appia* or Appian Way, the road that runs from the coast to the capital.

The Acts of the Apostles notes Paul's arrival in Rome: "[S]o we came to Rome. When the brethren there heard about us they came as far as the Forum of Appius and Three Taverns to meet us, and when Paul saw them he gave thanks to God and took courage" (Acts 28:14–15). Paul's journey along the *Via Appia*, during which he would have been bound and escorted by Roman soldiers, suggests a parallel to the journey down the *Via Dolorosa* that Christ made on his way to crucifixion and death.[13]

Knowledge, zeal, and creativity may have marked Paul's work (cf. 1 Cor 1:8–2:5; 2 Cor 11:5–6), but he gloried in and even boasted of his weaknesses (see 2 Cor 12:9; cf. Gal 6:14). He knew that ultimately these were the final word in his authentic testimony to the Crucified, the source of his strength (cf. Phil 4:13–14). At the end of the day, Paul's sufferings sealed the veracity of his gospel, for which he was willing to make the ultimate sacrifice of his life.

Prayer

St. Paul,
your life and mission were far-reaching,
and you greatly influenced the Church
in its infancy and throughout the centuries.
We think of you always busy about the Lord's work,
and often forget that you spent many years in prison.

But the confining walls of jail,
and the continual surveillance of guards,
did not keep you bound,
immobile, constrained.
Although a prisoner, you were free
because your heart was free!

Help me to look upon the difficult circumstances in my life
as stepping stones, not hindrances.
Constrictions such as illnesses, disappointments, setbacks,
or whatever other suffering I may endure,
can become for me, as they were for you, ways
to "bear the death of Jesus in our bodies
so the life of Jesus may *also* be revealed in our bodies"
 (2 Cor 4:10).

Paul, the Apostle, prisoner for the Gospel,
you remind us that
"Christ freed us for freedom" (Gal 5:1).
Pray for me,
as I seek true freedom in the Lord.
Amen.

Chapter IX

Paul's Crucified and Risen Jesus

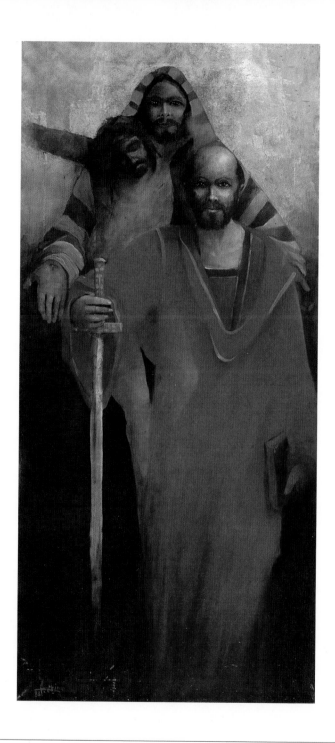

Vincenzo Cerino. *The Kerygma* (1984), oil on canvas (1.95 m. x .95 m.). Private collection. Courtesy of Vincenzo Cerino.

I consider that the sufferings of the present time
simply don't compare with the glory to come....

<div align="right">

ROMANS 8:18

</div>

The creative and remarkable work titled *The Kerygma* (the preaching of the Good News) is the original masterpiece of Vincenzo Cerino, a contemporary Italian artist born in Naples, Italy, in 1931. The artist, when questioned about the figures in his painting, identified the Apostle Paul standing in the foreground, with the image of Jesus crucified behind him, and the risen Christ on the upper level. The artist's intention for this gradation of images is for us to see Paul as the projection of Christ crucified and risen. From the upper level of the painting the risen Christ generates a forward movement as he extends his right arm in the act of sending Paul, who appears ready to move forward with confidence and commitment. He stands in front of Christ but a bit to one side, revealing Christ's right hand with its glorious wound. The crucified Jesus appears as a shadowed figure, his arms partially visible while his legs are superimposed on Paul's seemingly incomplete torso, giving the appearance of an all-encompassing presence that is there to remain.

Parallels can be seen here between the images of the crucified and risen Jesus and the that of Paul; the Apostle stands holding his cross-shape sword, referring to his suffering and death while underscoring his words: "I've been crucified with Christ!" (Gal 2:19). Applying to Paul the words of Isaiah: "He made my mouth like a sharp sword …" (Isa 49:2), we can assume further that the sword in the context of this painting is not as much Paul's attribute as it is a symbol for God's word, which Paul proclaimed and which has the ability to penetrate into our

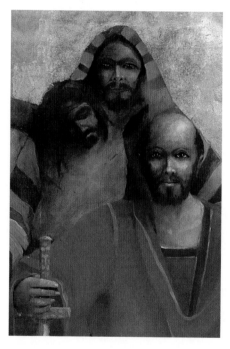

daily lives. The author of the Letter to the Hebrews writes: "For the word of God is living and active, sharper than any two-edged sword. It pierces to the dividing line between soul and spirit, joints and marrow, and it can discern the innermost thoughts and intentions of the heart" (Heb 4:12).

The artist chose another technique with which to parallel Paul with Christ: giving them physical similarity. Paul's facial features are mirrored in those of Jesus, as seen in the round face and penetrating eyes, the identical nose structure, the full lips, and the stylishly shaped beard. The similarities may be accidental; the artist's decision to give both persons the same facial structure may have been unconscious or a mere coincidence. On the other hand, it may indicate a deliberate choice to visualize the reality of Christ living in Paul.

Paul's declaration: "It's no longer I who live, it's Christ who lives in me!" (Gal 2:20), does not destroy Paul's personality, his particular quirks or mannerisms; in fact, he remains as "colorful" as ever and with definite room for improvement. As we've seen, Paul can be abrupt and hot-tempered, showing signs of aggressiveness, impatience, and a true stubborn streak. At his conversion Paul made a foundational choice to live in Christ, and that choice gives direction to his entire life and mission. This did not, however, mean an end to the struggle to "put on" Christ.

Paul is not afraid to show his emotions—whether of frustration, anger, zealous passion, vulnerability, or love. He feels deeply, and he freely displays his feelings no matter how unpleasant they are.

> I wrote what I did so that when I came I wouldn't receive pain from those who should have given me joy.... I was in tears when I wrote to you, and what I wrote came from my troubled and anguished heart. My intent was not to cause you pain but to let you know how great my love for you is. (2 Cor 2:3–4)

Paul was misunderstood, and at times he himself was a "thorn" to others because of his high expectations and demands (cf. Acts 15:37–40, 16: 36–39). But he is not a half-hearted person. Paul burns with one love only: Jesus Christ.

Returning to the painting, we see that Paul wears an itinerant traveling cloak, painted in flaming red to image for us the ardent zeal and love that impelled him to declare: "[W]oe to me if I *don't* proclaim the good news!" (1 Cor 9:16).

The painting also evokes another passage from Paul's writings: "My goal is to know him and to understand his sufferings ..." (cf. Phil 3:10). The "knowledge" Paul seeks, however, is not academic. Rather it is a knowing that implies intimacy of mind, will, and heart with Christ. Paul further expresses his desire to understand Christ's sufferings by

sharing in them. It is as if Paul is asking to feel and experience what Jesus felt and suffered. That is how intimately Paul chooses to identify with Christ. The author of the Acts of the Apostles and the Gospel of Luke seems to indicate that Paul's yearning to suffer as Christ suffered became a reality in his life. By paralleling Paul's journey to martyrdom with Christ's "Way of the Cross," the writer has made a concerted effort to portray Paul in total identification with Christ—what Blessed James Alberione has referred to as christification—"It's no longer I who live, it's Christ who lives in me!" (Gal 2:20).

JESUS' WAY OF THE CROSS	PAUL'S WAY TO MARTYRDOM
1. Jesus enters Jerusalem. *(Lk 19:28)*	1. Paul goes up to Jerusalem. *(Acts 21:15–17)*
2. Jesus is questioned by the Sadducees about the resurrection of the dead. *(Lk 20:27)*	2. Paul is brought before the Sanhedrin to defend himself. The topic of the resurrection is discussed. *(Acts 22:30–23:11)*
3. There is a conspiracy against Jesus. *(Lk 22:1–6)*	3. A plot to have Paul killed is discovered. *(Acts 23:12)*
4. Jesus is arrested. *(Lk 22:45)*	4. Paul is arrested. *(Acts 21:33)*
5. Jesus stands trial before Pilate, procurator of Judea. *(Lk 23:1–2)*	5. Paul stands trial before Felix, procurator of Judea. *(Acts 23:23–35)*
6. The chief priests and the elders present the charges against Jesus. *(Lk 23:10)*	6. The high priest Ananias brings charges against Paul. *(Acts 24:1ff.)*
7. (No parallel in Christ's life)	7. Paul remains in prison for two years until the new procurator, Festus, arrives. *(Acts 25:1–12)*

8. Pilate refers Jesus to Herod, who has come down from Galilee, so he can hear the case. *(Lk 23:7)*

8. Festus refers Paul's case to King Agrippa, who is visiting. *(Acts 25:13–26)*

9. Pilate declares Jesus' innocence: "I have not found this man guilty of the charges you brought against him nor did Herod...." *(Lk 23:13)*

9. Agrippa tells Festus that Paul has done nothing deserving of death or imprisonment. *(Acts 26:31)*

10. Jesus is condemned to death. *(Lk 23:26)*

10. Paul will stand trial before Caesar. *(Acts 25:12)*

11. Jesus makes his way to Calvary, carrying his cross under the escort of Roman soldiers. *(Lk 23:26)*

11. Paul makes his way to Rome. He is kept in chains and escorted by Roman soldiers. *(Acts 27:1–5)*

12. According to tradition, Jesus falls along the way.

12. Paul is shipwrecked. *(Acts 27:39–41)*

13. Along the *Via Dolorosa*, Jesus meets his mother and the holy women of Jerusalem. *(Lk 23:27)*

13 Along the *Via Appia*, the Christians of Rome come out to greet Paul. *(Acts 28:14–15)*

14. Jesus is nailed to the cross and dies. *(Lk 23:33)*

14. According to tradition, Paul suffers imprisonment and death through decapitation.

Parallels between Jesus' final days recorded in the Gospel of Luke and those recorded of Paul in the Acts of the Apostles are obvious. Paul would have played down such a comparison. The similarities between the two point rather to the work of Paul's disciples, who, after reflection, prayer, and meditation, helped these parallels emerge.

Paul's consistent message is only this:

"I bear the marks of Jesus in my body!" (Gal 6:17).

"[W]e always bear the death of Jesus in our bodies so the life of Jesus may *also* be revealed in our bodies" (2 Cor 4:10).

For Paul this conformity is not reserved to the end of his life, however. The Apostle knows that he lives "in" and "with" Christ, conforming to Christ's total self-emptying by sharing in his sufferings (cf. Phil 1:29). Throughout his life Paul challenges Christians to imitate him as he in turn imitates Jesus (cf. 1 Cor 11:1), becoming like him in every way. According to Paul, this is conformity with the pattern of Christ.

Loneliness, weariness, and separation from those he loved are part of the sufferings associated with Paul's passion: "Even when we came to Macedonia our bodies had no rest. We were afflicted in every way —conflicts without, fear within" (2 Cor 7:5). Like Paul, we too may sometimes feel forgotten, left alone to experience darkness, anguish, deprivation, and desolation. We desire comfort and seek solidarity, and yet we may feel abandoned. But as it was for Paul, suffering—lived in solidarity with the crucified Christ—can become for us a most powerful means of purification.

How can this be so? If we strive to live with an attitude of openness to Christ, who reawakens us to new life each day, we will gradually live the circumstances of daily life by assuming Christ's sentiments of humility and gentleness, of love and mercy, of service and joyful availability, of tireless zeal for the Father's glory and for the salvation of the human race.

As it did for Paul, life for us will always have its challenges, its times of sorrow, pain, tension, and lack of pleasure and beauty. But what are our options? We must choose joy in the midst of pain. We must choose freedom from fear. We must choose beauty over chaos and conflict. St.

Paul declares to us that our suffering, united to Christ's suffering, becomes beatitude and joy.

Prayer

St. Paul,
help me to live the close identification with Christ
that you lived on earth,
accepting in a spirit of purification the sufferings
 that life deals,
and trusting that in my daily dying
my "life is hidden with Christ in God" (Col 3:3).
I will try to "seek the things that are above,
where Christ is seated at God's right hand
and when Christ, my life, appears,
then I too will appear with him in glory" (cf. Col 3:1, 4).
Amen.

Chapter X

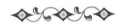

A Life Spent
for the Gospel

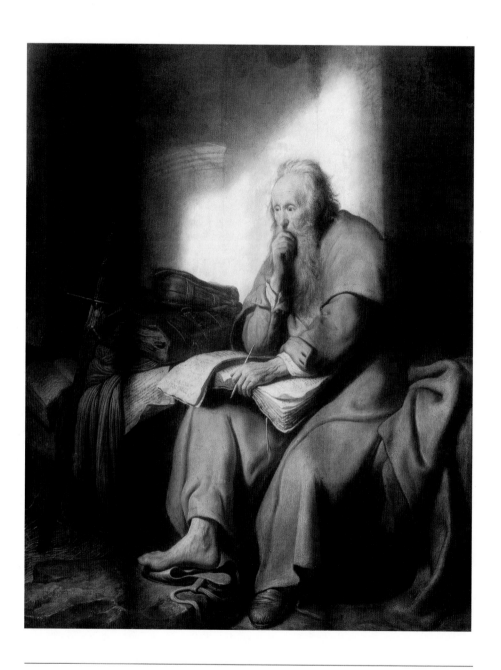

Rembrandt van Rijn (1606–1669). *St. Paul in Prison* (1627), oil on panel, Staatsgalerie, Stuttgart, Germany. © SuperStock, Inc. / SuperStock.

One of Rembrandt van Rijn's earliest works, *St. Paul in Prison*, dates back to 1627, when the artist was only twenty-one years old. The original was painted on canvas and measures approximately twenty-four by twenty-nine inches.

Rembrandt's composition of this painting merits closer scrutiny. For this reason we begin by considering the lines and geometric shapes in the painting as a way to discover where the artist wanted to draw our attention, a roadmap of sorts to his work. Some art theorists suggest that a viewer's positive sensations of piety, awe, ecstasy, or negative feelings of discomfort or repugnance for a work of art are generated solely by the work itself; this type of theory is referred to as response criticism.

Applying this theory to Rembrandt's painting, we first notice Paul's placement to the side and foreground, close to the viewer. This creates an interesting funnel effect, with Paul at the mouth of the funnel and

the bounded parchments receding slightly into the middle ground, while further back darkness dominates. The dimensional effect serves to highlight Paul as the central figure of the painting while still alluding to the feelings the elderly Paul may have of being "put aside" and forgotten (cf. 2 Tim 4:11, 16). Dominant vertical lines are composed by the figure of the Apostle and by the colossal Roman column. As our eyes move around the prison cell, we note the well-defined diagonal lines of the descending light behind Paul, the sword, and his pen, suggesting to the viewer that these are important. Namely, the embracing light implies the comfort and warmth of God's presence despite the harshness of jail life; the sword foreshadows Paul's death; and the pen, his apostolic fruitfulness during his time in prison from where he wrote extensively to his churches. Another visible shape in the work is a large inverted triangle formed from the top of the sword to Paul's left shoulder, then down to the heel of his right foot, and back up again to the sword. The triangle may possibly allude to the Trinitarian presence of God alive in Paul, or it may be an attempt to draw our attention to the book of letters at the center of the painting.

Paul's rounded eyes, forehead, and shoulders, and the Roman column contrast with the razor-sharp edge of the sword, the straight beam supporting Paul's back, and the raised floor slab on which he rests his foot.

Proponents of response criticism further suggest that the uneasiness and discomfort created by all the lines and shapes is meant to produce a response of compassion for the prisoner's long sufferings and vulnerable state. The colossal Roman column, for example, represents the imposing Roman authority that keeps Paul imprisoned, and the intimidating presence of the sword frightens us and moves us to empathy. The theorists of response criticism would say that apart from our opti-

cal vision, we look at images with sensory vision, which means that we project onto what we see our experiences, moods, sensations, and emotions. So as we look at Paul sitting in prison, we gaze upon him through the lenses of our personal feelings. We may project onto him our own feelings of tiredness, anxiety, or smallness before the gigantic task of evangelization, or whatever other emotions we may be undergoing at that moment.

Although the theory of response criticism has merit, it seems subjective, and it limits our exploration of devotional art. With devotional art, we need also to consider religious beliefs, practices, and rituals; for this reason, our response can never remain merely personal. Response criticism, moreover, is inadequate when engaging in an exegesis of devotional art, which demands content and meaning. As it speaks from a specific faith tradition, Christianity has harnessed the potential of devotional images to educate, reveal, connect, transmit, enthrall, and inspire, using them to communicate the person of Jesus Christ and his message in ways that deeply stir the human heart. This happens when we move from a response experience to considering the subject matter in order to arrive at its intrinsic sense or meaning. Approaching devotional art from this perspective, we discover a never-ending source of meaning.

Rembrandt's painting is made even more meaningful when we consider a modern-day patriarch, a man of great stature and complete dedication to God, Pope John Paul II. He, too, lived his years of diminishment and illness in the public eye, giving an example of serenity and acceptance, while encouraging others to strain ahead to the prize, which is Christ Jesus. Shortly before John Paul died, he wrote to the elderly, reminding them that their mature experience gives them the opportunity to offer to young people precious advice and guidance. "Human

frailty demands mutual dependence between the young and the old."[14] In Paul's life, this is well demonstrated by his dependence on Timothy (cf. 2 Tim 4:9). Paul, who had been self-sufficient all his life, now turns to Timothy for help, companionship, youthful enthusiasm, and information from those places Paul can no longer visit. Timothy, on his part, is grateful to Paul as a son is to a father and teacher.

Returning to the colors used in the painting, we note that such a bleak prison scene could have been painted in shades of gray and concentrated black, yet, by adding a light source, the same prison is illuminated by a warm color palette of soft yellow, orange, and brown tones. Although these colors are typical of Rembrandt's works, in this painting they manage to further convey the warmth in Paul's heart. The Apostle has been set aflame for Jesus Christ, the messenger sent by the Father who has become the Message preached by Paul. The light could be coming from a high window behind the prisoner that allows the midafternoon sun to warm the damp cell and give him sufficient illumination to pursue his writing. The descending radiance flooding Paul may also be of a revelatory nature. But most likely the source of the light is a window in front of Paul that illumines the scene and throws a soft glow on the back wall.

Various elements suggest a season late in the year—fall or perhaps winter. Paul's heavy cloak, the two long-sleeved jackets he is wearing, and the scarf lying on his cot point toward a cooler climate. In spite of this, one of Paul's feet is shoeless and elevated. These elements further elicit our sympathy and compassion; the prisoner appears as a fragile, bent figure with an unfocused gaze, feet that may be swollen or injured, and hands that are wrinkled and possibly arthritic.

Paul was imprisoned several times for preaching the Gospel, but even during these difficult times he continued his ministry by writing

letters, often referred to as the Captivity Letters. The painting *Paul in Prison* symbolizes all that this tireless Apostle has endured, sacrificed, and labored for during his life. The painting's intrinsic meaning might be summed up in the phrase: "A life spent for the Gospel." Apparently Rembrandt's purpose is to give us a portrait of a patriarch—like the patriarchs of old, whose heroic faith made them appear larger than life—yet one clothed in the vulnerability of an aged, humbled, and lonely man. Paul depicted thus leads us to reflect on how he must have learned to accept the diminishment and the hardships of old age. Yet he has the tremendous satisfaction of knowing that he has spent himself entirely for the Gospel of Jesus Christ.

> My life is already being poured out like a libation—the time of my departure is imminent. I've fought the good fight, I've finished the race, I've kept the faith. From here on the crown of righteousness is being laid aside for me, which the Lord, the just judge, will award me on that day, and not only me but all those who have longed for his appearance. (2 Tim 4:6–8)

Prayer

When I was young,
the elderly were people to be revered,
assisted, respected,
but I didn't easily see beyond the bent and broken bodies
to discover the life and fire
in their souls.

As I grew older,
and the gap between me and the elderly began to narrow,
my vision changed.
Now, the older persons are no longer merely to be pitied
or paid lip service for their wisdom.

While there is physical diminishment,
the ravages of illness of body and mind,
the feelings of aloneness and even abandonment,
the older person's spirit often continues to be youthful,
 alive, ablaze,
holding on to life, revealing the human person's call
 to live eternally.

This contrast of an aging body with a still youthful spirit
is the great suffering of many of the elderly.
For others, the process of aging
is less merciful,
leaving its mark in a clouded mind and broken body.

The words of St. Paul come to mind:
"… for although our outer self is wasting away
our inner self is being renewed, day by day."

"… [A]nd so we keep our eyes on what is unseen
rather than on what can be seen,
for what can be seen is transitory
but what is unseen is eternal" (2 Cor 4:16, 18).

Lord, be my companion as I travel the process of aging.
Amen.

Chapter XI

The Martyr

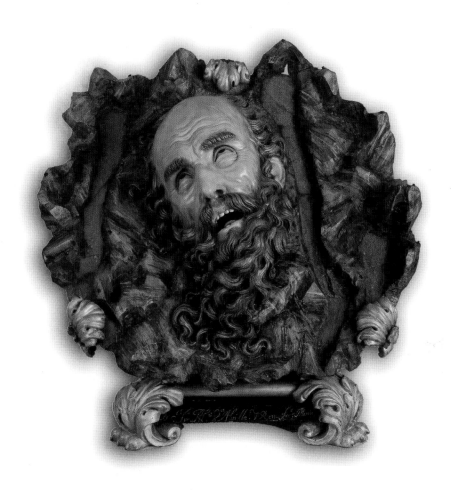

Juan Alonso Villabrille y Ron. *Cabeza de San Pablo* (1707). © Museo Nacional Colegio de San Gregorio, Valladolid, Spain.

The art piece titled the *Head of St. Paul*, signed and dated in the
year 1707, is the work of the Spanish sculptor Juan Alonso
Villabrille y Ron (1663–1728). This wooden sculpture is a polychrome
work, meaning that the wood is painted. The artist chose to use brown
hues that convey the color of good, fertile dirt. The decapitated head of
the martyr Paul was the first work this artist produced, followed by
other religious masterpieces, but Villabrille was also known in Spain as
a molder of sculptural models. All of his work, including the *Head of St.
Paul*, exhibits elegance and a highly ornamental style, enhanced by the
use of decorative polychrome. Villabrille's pieces are classified among
the best works of Spanish baroque art, which is characterized by real-
ism, precision in detail, and elaborateness. They are also distinguished
by their ornate style, curved shapes, and dramatic gold decorations.

The vivid display of agony on Paul's face gives the work the appearance of a snapshot taken at the very moment of the Apostle's martyrdom. It shows a face suffering torment, yet with no trace of resistance. Trailing down from Paul's oblong face is a curly, swirling beard. He is partially bald, a feature consistent with the iconography of Paul. The face is that of an older man with deeply etched lines, sunken cheeks, and swollen eyes lifted toward the heavens, ready to meet Christ.

The backdrop of the sculpture is carved to give the appearance of reddish rocks or dirt on which the decapitated head of Paul has apparently fallen. Instinctively we connect this image to the parable of Jesus, describing the seed falling to the earth to produce a great harvest (cf. Matt 13:18–34). Two indentations running along both sides of Paul's head are visible, and a third but smaller indentation can be discerned on the lower right side of the carving. They seem to refer to the three streams of water that, according to tradition, sprang up at the spots where Paul's head touched the ground. A brief description featured on the Website of the Museo Nacional de Escultura in Valladolid, Spain,[15] notes the artist's use of glass crystals to represent the three streams of water.

As previously mentioned, the Apostle's eyes appear swollen, possibly indicating that he went to his martyrdom in tears. If so, such tears would not have been shed out of pity for himself or out of fear. Knowing Paul as we do by now, and knowing his longing to be with Christ, the anguished sorrow is for the parting from his closest friends, collaborators, and brethren. Paul is a man capable of forming deep and lasting friendships. The awareness of loss and separation would naturally cause him to weep. The Acts of the Apostles earlier gives us a beautiful insight into Paul's heart when it narrates his tearful separation from his Christian brothers and sisters at Miletus:

"Watch over yourselves and all the flock, in which the Holy Spirit has appointed you … to shepherd … I know that after my departure savage wolves will come to you and will not spare the flock.… So stay awake; remember that for three years, both night and day, I didn't cease exhorting each one of you with tears. And now I commend you to God and His word of grace, which can build you up and give you an inheritance among all His holy ones." …After saying these things he got on his knees and prayed with them all. They all wept a great deal and embraced Paul and kissed him, because they were especially pained by what he said about never seeing his face again. (Acts 20:28–29, 31–32, 36–37)

Paul so identifies himself with Christ that martyrdom is the inevitable result of a life lived in imitation of the Master. Christ's own *kenosis*, or self-emptying, is understood as his personal identification with all men and women, while remaining who he is—fully divine, fully human. Throughout his life Paul proclaims the Gospel; in death, he conforms fully to Christ's ultimate self-emptying. This becomes the reason that Paul, with humility and sincerity, declares that we could imitate him as he imitates Christ.

We know Paul's thought regarding his death; he had earlier written that he preferred to be with the Lord, which was "far better" than remaining on earth "in the flesh" (cf. Phil 1:20–25). Whatever happens to him, the important thing for Paul is that he is manifesting Jesus Christ: "… now as always Christ will be boldly honored in my person whether I live or die" (Phil 1:20). The following words certainly do not reflect a person fearful of death: "… [W]e always bear the death of Jesus in our bodies so the life of Jesus may also be revealed in our bodies.… [W]e don't lose heart, for although our outer self is wasting away, our inner self is being renewed, day by day" (2 Cor 4:10, 16).

During his lifetime Paul's goal was to "witness in his body the life of Jesus" (cf. 2 Cor 4:10), and dying for Christ was the supreme grace

Paul was eager to accept. He was certain that his suffering and death could only contribute to the fruitfulness of his ministry; for that reason "to die is gain" (cf. Phil 1:21).

Even in death, therefore, Paul identifies with Christ. We too are called to live and die in Christ. He is our final destination, our ultimate goal. Like Paul, we long for the day on which we will gaze upon the loveliness of the Lord. Until then, we are content with the knowledge that he lives in our own hearts and in each brother and sister. And daily we grow in the conviction that nothing, including death, can separate us from him. With the Apostle Paul we say: "I'm convinced that neither death nor life, neither angels nor principalities, neither things present nor to come nor powers, neither height nor depth nor any other created being will be able to separate us from God's love in Christ Jesus our Lord" (Rom 8:37–39).

Prayer

St. Paul, apostle and martyr,
your life and especially your death
have become prototypes
for many followers of Jesus.

Martyrdom continues to take place today.
For some who courageously speak of the Lord
and witness to him with their lives,
this martyrdom is often bloody, cruel, agonizing.

But there is also another martyrdom,
not visible, but still staggering:
the martyrdom of daily fidelity—
　　to our values
　　our commitments,

our beliefs,
to people,
to God.

And all of us are called to it.

The Lord is faithful and will strengthen you
and protect you from evil (cf. 2 Thes 3:3).

Chapter XII

The Saint

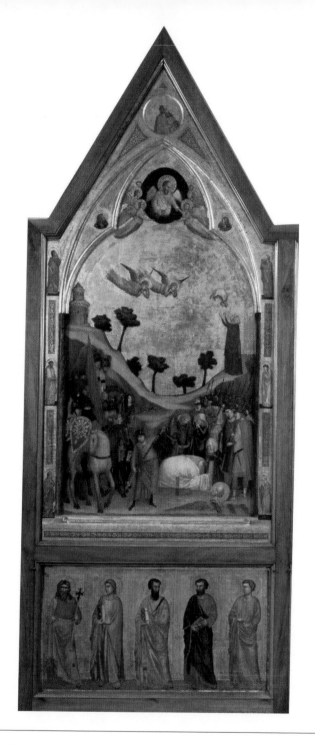

Giotto di Bondone (1266–1336). *The Stefaneschi Triptych with Christ Enthroned.* Left Panel: *Saints James and Paul.* Pinacoteca, Vatican Museums, Vatican State. Photo credit: Scala / Art Resource, NY.

*… God works in every way for the good with those
who love God and are called in accordance with His plan.…
[T]hose He called He restored to His fellowship, and all those
whom He restored to fellowship He also glorified.*

<div align="right">Romans 8:28, 30</div>

This work of art is part of a triptych with the central panel featuring the enthroned Christ, surrounded by angels. This panel is flanked on the left by the martyrdom of St. Peter and on the right by the martyrdom of St. Paul, which is the section we are considering here. Cardinal Jacopo Stefaneschi commissioned Giotto di Bondoni, an artist and architect from Florence, Italy, known simply as Giotto, to paint this majestic work around the year 1330. Thus the work became known as the Stefaneschi Triptych. At one time it may have hung in the old St. Peter's Basilica in Rome; now it finds a protective home in the Pinacoteca, or art gallery, in the Vatican Museum.

The panel depicting Paul's martyrdom can be divided into three levels. On the ground level, right in the center of the painting, we see a soldier placing his sword back into its sheath after having carried out the execution. The Apostle's body rests on the ground next to his

decapitated head. Just below Paul's decapitated head, three small streams of water appear. As previously mentioned, tradition maintains that water sprang up into fountains marking the spots where Paul's head touched the ground.

Circling Paul are his disciples or friends—two women and a man— in postures of sorrow and heaviness over the loss of their spiritual father. Standing off to the side is a large group of foot soldiers holding spears. They are mirrored on the opposite side by an equal number of cavalry brandishing their shields. One of them blows a trumpet, announcing the completion of their gruesome task. The soldiers, merely doing their job, demonstrate no emotional connection to the brutality of the act just committed.

Moving up to the middle of the panel, we see two hills connected by a valley standing against a golden background, which seems to stretch the landscape into a vast emptiness. On the right and slightly lower hill stands a woman, her hands raised to receive a white cloth parachuting down. On the left hill stands a structure that has been recognized as the lighthouse of the port of Ostia, indicating the general

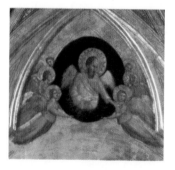

area where, according to tradition, Paul's decapitation took place. Six trees rise from the valley, above which two winged angels hover.

On the third and uppermost level of the painting six angels, three on each side, hold a circle revealing the figure of the Apostle Paul in glory, depicted with wings and a halo. Paul's arm reaches down toward the woman who is receiving the veil. The three levels to the painting indicate a time sequence. This lapse in time is important in understanding the icon, for the woman kneeling next to

Paul's decapitated body is the same woman who stands on the hill accepting his gift. The Apostle has now ascended into heaven to receive the crown of the faithful servant. "I've fought the good fight, I've finished the race, I've kept the faith. From here on the crown of righteousness is being laid aside for me" (2 Tim 4:7–8).

This painting depicts the narrative found in a Medieval book titled *The Golden Legend* about the noblewoman Plautilla, who was a disciple of Paul and who accompanied him to the place of his martyrdom. As the story goes, on his way to martyrdom Paul asked to borrow Plautilla's veil, promising to return it later. In *The Golden Legend*, Paul is quoted as saying to her, "Farewell, Plautilla, daughter of everlasting health, lend me thy veil or keverchief (sic.) with which thou coverest thy head, that I may bind mine eyes therewith, and afterwards I shall restore it to thee again."[16]

The icon captures the moment when Plautilla receives her veil back from Paul as promised.

Tradition attests that St. Paul's martyrdom occurred at a place already known in Roman times as *Ad Aquas Salvias*, meaning "healing waters." Excavations there have confirmed the legitimacy of this tradition by identifying the remains of an oratory and subsequent chapels at the site. The present church built there, known as *San Paolo alle Tre Fontane* or St. Paul of the Three Fountains, was erected in 1599. Inside the church, and built over the fountains, are three identical altars carved with the head of Paul in relief. Although the fountains were sealed in 1950, today pilgrims to this holy site are still reminded of the tradition of the three fountains by the occasional murmur of water.

Paul's martyrdom is not the only reason we hail him as a saint. Martyrdom was his final witness to Christ, but Paul's sanctity was intertwined with his daily living of the life of Jesus: "It's no longer I

who live, it's Christ who lives in me! And this life I live now in the flesh, I live through faith in the Son of God, who loved me and gave himself up for me" (Gal 2:20–21).

Paul was a man marked by great authenticity, and in this spirit he could declare: "Be imitators of me, just as I imitate Christ" (1 Cor 11:1).

What exactly was there to imitate in Paul? What virtues did he witness to? Again we look to the Apostle's writings to obtain a closer glimpse of this saint:

"So then, let's continue to do good to everyone as long as we have time ..." (Gal 6:10).

"Love is patient, love is kind, it isn't jealous, doesn't boast, isn't arrogant. Love is not dishonorable, isn't selfish, isn't irritable, doesn't keep a record of past wrongs. Love doesn't rejoice at injustice but rejoices in the truth" (1 Cor 13:4–6).

"I'd gladly spend all my money and utterly exhaust myself for your souls" (2 Cor 12:15).

"Don't pattern yourselves after the ways of this world; transform yourselves by the renewal of your minds, so you'll be able to discern what God's will is, what is good, pleasing, and perfect" (Rom 12:2).

A saint is not one who is perfect. Paul had many flaws, and he, too, struggled with the inclinations of a sinful human nature: "... [F]or instead of doing the good that I want to do, I do the evil thing that I *don't* want to do. Now if I do the very thing that I don't want to do, that means it's not me doing it, it's sin dwelling within me that's doing it" (Rom 7:19–20). But consistent with the demands of holiness, Paul has the capacity for reconciliation with God and others. What makes him a saint is his total commitment to God, along with his unwavering trust in the grace won for him by Jesus Christ (cf. Rom 7:24–25).

Paul's encounter with Jesus on that dusty road to Damascus radically transforms him. In that moment of revelation, he becomes aware of how infinitely loved and cherished he is by God. This is an experience of love that touches every aspect of Paul's life; nothing will ever again be the same. Confronted by such an experience of love, he surrenders every defense and embraces his absolute dependence upon God. From that day forward, no other response is possible for Paul than to acquiesce to God's loving plan for him.

Prayer

Christ is my life,
my love,
my goal,
my purpose,
my wish,
my teaching,
my every action is Christ.

I wish nothing else,
I know nothing else,
I boast of nothing else,
I delight in nothing else,
I think of nothing else,
I yearn for nothing else,
I speak of nothing else,
I desire nothing else,
I live nothing else other than Christ.[17]

Chapter XIII

Paul,
the Universal Teacher

Aronne del Vecchio. *St. Paul the Apostle* (1961). Basilica Minore Santa Maria Regina degli Apostoli, Rome, Italy. Photo: Mary Emmanuel Alves, FSP.

Our hope is that as your faith increases the scope of our activity will be greatly enlarged, so that we'll be able to proclaim the good news to lands beyond you....

2 CORINTHIANS 10:15–16

The Italian artist Aronne del Vecchio painted this fresco of St. Paul in 1961 at the request of Blessed James Alberione, founder of the Daughters of St. Paul and the other religious institutes that make up the Pauline Family. The city of Rome was celebrating the centenary anniversary of the Apostle's arrival there. To mark the occasion, Alberione commissioned two altars for the Queen of Apostles Basilica, the church he had built after World War II in honor of the Madonna. One altar was to feature a painting of Jesus, the Divine Master or Teacher; the other, his faithful disciple, Paul. Blessed Alberione expressed the desire that the painting of Jesus appear directly across from that of Paul, indicating that Jesus was the sole inspiration and model for the Apostle's life and teaching.

For Alberione, Paul was the most faithful guide in the following of Jesus. The painting, which depicts St. Paul in glory, visually represents the centrality of the Apostle Paul in the life of the Church. Paul holds

a place of prominence in the fresco, identifying him as a point of reference for how we as Christians are to know and live Jesus Christ and communicate him to the world. The marble archway encasing the fresco conveys the image of a large doorway, through which the viewer not only glimpses Paul's glory but also is invited to enter and be counted among the Apostle's devotees.

The fresco is divided into two parts. In the upper portion, Paul wears a red mantle over a green tunic. While the color red is usually associated with martyrdom, power, and love, green is often used to represent hope, victory over death, and newness of life. These colors consistently figure into the extensive iconography of Paul.

At his left side Paul holds a book and sword, symbols of his mission and martyrdom, which witness to his radical response to the following of Jesus. Here the closed book seems to suggest the "mystery to be revealed" (cf. Col 1:26) and announced to all people. Paul thus becomes the exemplar for those called to know, live, and announce the mystery of Christ.

Paul's sandals are planted firmly on the ground; these recall his journeys made to preach the Gospel, extending to lands where no one had yet arrived to announce the Good News of Jesus Christ. The Apostle's upright stance symbolizes his availability and readiness for service, while the hand placed over his heart suggests that what Paul transmits is the ardor of his love for Christ and his Church. The image reminds us that all Christians, called by baptism to share the spiritual richness they have received with others, are heirs of this great love.

In the fresco Paul stands against, above, and in front of layers of clouds, varying in gradation from dark to light until reaching the point of ultimate brightness. A radiant light streaming from the heavens floods Paul, whose eyes are raised in a gaze of contemplation. He seems

to be communicating to his devotees that their point of reference is not himself but Jesus Master, the crucified and risen Lord who chose Paul to be a "vessel of election" to the nations. The light cascades down-

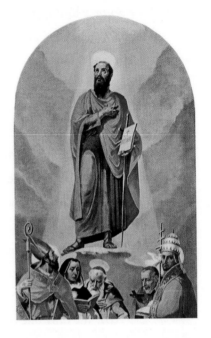

ward in a triangular shape, symbolizing the presence of the Trinity and recalling the moment of his encounter with the Divine as described in the Acts of the Apostles: "I saw a light more brilliant than the sun shining around me and those who were traveling with me" (Acts 26:13).

In the lower part of the fresco, we see that the light envelops not only Paul but also the group of men standing at his feet. These are various Doctors of the Church who drew inspiration from the great Apostle to the Gentiles. Paul was their teacher, the one who embodied for them in a particular way the doctrine of Jesus Christ and from whom they reaped the insight and knowledge they then shared with others. Blessed Alberione considered these saintly theologians particularly significant. They were successful in confronting the erroneous teachings of their times and in helping to form in their contemporaries a Christian mentality that realized "the embrace among the two sisters, science and faith."[18]

The figures are, from left to right:

St. Augustine: bishop, theologian, and Doctor of the Church. Under his left arm Augustine clasps a closed book, and in his right hand he holds the pastoral staff of a bishop.

St. Thomas Aquinas: theologian and Doctor of the Church. Thomas, nicknamed the "Angelic Doctor," peers intently into an open book. He wears the white and black habit of the Dominicans.

St. Bonaventure: bishop, theologian, and Doctor of the Church. The saint's eyes are lowered and his hand rests upon his heart. These are gestures indicating the humility of the "little brothers" of the Order of Friars Minor. Bonaventure, a Franciscan, is depicted in this fresco with the red biretta of his episcopal office as cardinal.

St. Alphonsus de Liguori: bishop, theologian, and Doctor of the Church. Alphonsus contemplates the crucifix, a reference to the Redemptorists, the religious order he founded.

St. Gregory the Great: pope and Doctor of the Church. Gregory's gaze is turned toward the viewer. He too holds a book and his pastoral staff. His office as supreme pontiff is indicated by the tiara, or triple crown, which, along with the dove whispering in his ear, is Gregory's traditional attribute.

Pope Leo XIII: the only one on his knees, possibly because he is the only figure in the painting not canonized. Leo's hands are joined in prayer, and his tiara rests beside him on the ground. This pope was highly significant to Blessed Alberione's mission.

These Doctors of the Church, taken as a whole, represent the Church—teacher and communicator—in its mission of presenting to the world the truth (i.e., religious teaching or doctrinal content), the life (of sacramental grace), and the way (or moral code) of Jesus Christ. The fresco also shows that a number of the saints, in addition to being portrayed with their traditional attributes, also carry a book representing their contribution to a particular area of expertise: St. Augustine, systematic theology; St. Thomas Aquinas, philosophy; St. Bonaventure, mystical theology; St. Alphonsus de Liguori, moral theology; and St. Gregory the Great, liturgical theology.

The inclusion of Pope Leo XIII is especially important for Blessed Alberione. This great pope wrote the encyclical *Tametsi Futura Prospicientibus* (On Jesus Christ Our Redeemer), which he promulgated on November 1, 1900. The document gave spiritual and apostolic direction to the then-sixteen-year-old seminarian James Alberione, preparing him for the mission of communicating Jesus Master, Way, Truth, and Life to the world in the manner of the great Apostle Paul. After ordination and throughout his life, Alberione's goal was to make the word of God known and proclaimed to his contemporaries, especially by using the modern media to reach a wider audience. But Alberione was not content to work alone in spreading God's word; through divine inspiration, and with the Church's approval, Alberione went on to found five religious congregations, four secular institutes, and a group of cooperators—ten religious groups in all. This huge army of consecrated and lay men and women who became known as the Pauline Family[19] has a particularly close relationship with St. Paul because Alberione had a great admiration for this saint.

Alberione considered St. Paul the saint of universality not only because, with Peter, he was a founding pillar of the Church, but also because Paul's message is for everyone. The priest's admiration of and devotion to Paul began through reading, study, and meditation on the Letter to the Romans. Writing in his memoirs, Alberione explains that "from then on, Paul's personality, his holiness, his heart, his intimacy with Jesus, his contribution to dogmatic and moral teaching, his impact on Church organization, and his zeal for all peoples—all became topics for meditation. Paul came across as *the* Apostle, and thus every apostle and every apostolate could draw from him."[20]

In the slab of marble under the fresco is inscribed in Latin: "St. Paul Apostle, Vessel of Election, Teacher of the Gentiles, Martyr and Protector of the Editions." These titles are more than engraved words

on a wall. Alberione's idea was to have his followers consider Paul, and not himself, as the true founder of the Pauline Family. Each of them was to aspire to be Paul living today through the "Apostolate of the Editions," a phrase that refers to the particular apostolic work of the Pauline Family, which has the mission to evangelize from within our media culture and, using the media themselves, to proclaim to the world Jesus Christ as Lord.

Prayer

I came from nothing,
was raised from dust,
placed among a believing people,
and made a minister of Christ.

All this in order to
better know you, my God—
through the Bible,
the Church,
and through nature.

To *believe* in you more firmly
so that one day I will arrive
at a profound vision of you, my God.

To *serve* you more generously
seeking your will in my life.

To *love* you more intensely
in a communion that is deeply felt, continual, intimate,
loving you above all things.

But I am aware of my sin and weakness.
Convert me, as you converted Paul.
I surrender.[21]

Conclusion

From the title of this book, *Facing the Apostle: Paul's Image in Art*, one can deduce differing assumptions and meanings. The first is that "facing" may mean looking at as related to fixing our eyes on Paul depicted in masterpieces by both our contemporaries and artists of old. This way of "facing" is similar to gazing at family pictures—the birthday gatherings, the seasonal memories, and monumental achievements. However, I intended the title to be understood in the sense of encountering, confronting—better yet, facing head-on—the person of Paul.

Facing Paul inevitably demands that he look back at us. This requires courage because we have to let our defenses down to allow Paul to engage us with his gaze. To face the Apostle Paul is to learn from him, to use him as our standard for imitating Christ.

My purpose for this book was to let the iconography of Paul, which is abundant and diverse, reveal something of his person, his fruitful life, his spirit, and his passion for the Christ. What I have discovered when looking at art, specifically devotional art, is that one cannot remain on the exterior or facade of the work, skimming its flat surface. Almost without realizing, we discover ourselves to be participant, as if the artist

has left a portal for us to enter into the masterpiece. By participation and by confronting Paul face to face by means of the art presented, I pray that our eyes remain open so we can continue to catch glimpses of the invisible.

With an open heart, let us receive Paul's blessing:

> May God fill you with the knowledge of His will through wisdom and all manner of spiritual understanding, that you may conduct yourselves in a manner worthy of the Lord and fully pleasing to him—fruitful in every type of good work and increasing in knowledge of God. We pray that you will be strengthened with all the power of His glorious might so that your steadfastness and patience will be perfected and you may joyfully give thanks to the Father Who made you worthy to share in the portion of the saints in light. (Col 1:9–12)

Appendix I

Questions for Personal or Group Discussion

The citations offered do not pretend to exhaust the subject matter of each question; they are simply springboards for further insight and reflection on the writings of St. Paul.

1. What does "living in Christ" or "putting on Christ" look like?
 Gal 2:20; Rom 6:11; 1 Cor 1:30; Eph 3:17; Col 1:27

2. What impact can Paul's "goodness" have in my daily life?
 2 Cor 5:17; 1 Cor 3:1–4; Gal 2:19–21; Eph 2:1–22; Col 3:1–17; Gal 5:1; Rom 8:1–8

3. How do Paul's sufferings speak to me?
 2 Cor 4:7–11, 6:3–10, 7:5; Phil 1:12–13; 1 Thes 3:1–5; 2 Tim 4:9–18

4. Paul seems to turn upside down the concepts of "power" and "weakness." How do these concepts resonate in my heart?
 1 Cor 1:27–31, 4:10–13; 2 Cor 12:7–10, 11:30

5. How do Paul's writings contribute to my understanding of the Eucharistic celebration?

 1 Cor 11; 1 Cor 10:16–17; 1 Cor 11:18–34

6. What insights does Paul give me with regard to the polarization we might sometimes experience in the Church today?

 1 Cor 1:10–16; 1 Cor 12:12–30; Eph 2:11–22; Eph 4:1–16; Phil 2:1–11; Rom 14

7. What can be said about St. Paul's style of leadership?

 1 Cor 1:12–13; 2 Thes 3:14; 2 Cor 6:11; 2 Cor 4:1–2; 1 Thes 2:6–8; Titus 2:7

8. What are some of Paul's great metaphors?

 Athlete: 1 Thes 5:7–8; Runners, race: Phil 3:13–14; Rom 9:16; 1 Cor 9:24; Phil 2:16; Bride of Christ: 2 Cor 11:2–3; Aroma: 2 Cor 2:14–16; and others

9. How does my own encounter with Christ compare with Paul's life-changing event on the road to Damascus?

 Acts 26:13–17

10. In the Letters of St. Paul we discover prayers that are both theological and filled with love, care, and blessings for the readers. What is my favorite Pauline prayer?

 Eph 3:14–21; Rom 16:25–27; Eph 1:6–8; 1 Cor 1:4–9; Col 3:1–4; Eph 1:3; 1 Thes 5:23–24; 2 Thes 3:16; and others

11. If Paul were writing to the Church today, what might he say? What issues would he address?

12. In moments of prayer with St. Paul, what would I want to share with him about the challenges I face in my life and in my efforts of evangelization, of proclaiming the Gospel to those around me?

Appendix II

About the Cover

I was first attracted to this image of St. Paul because of the colors, which are imaginative and contemporary: the watermelon red of his sword, the kiwi green of his cloak mixed with diversified shades of ocean blue on his tunic. But the abundant gold ornamentation along with the brocaded design in the background were strong indications that it belonged to a time past.

This work of the Renaissance artist from Venice, Carlo Crivelli, is dated around 1473. The image of Paul, a detail of which appears on the cover of this book, is one of twenty-one sections of an altarpiece commissioned for the Blessed Sacrament Chapel of the Cathedral of St. Emidio in Ascoli Piceno, Italy.

What is Crivelli revealing about the person and the life of the Apostle of the Gentiles? The original painting consists of a full-length view of Paul down to his sandaled feet, positioned one foot in front of the other, thus conveying to the observer the immediacy or the readiness to act. The most notable and imposing feature is the elaborate

sword, which is gigantically out of proportion to the figure of Paul. The fingers of his right hand grip the sword hard.

The other hand clasps the written Word of God symbolized by the book. The book is heavy and awkwardly held, as shown by the strained muscles and veins in Paul's left hand. The first few words of Latin text on the book are legible. From the Letter to the Romans, they are rousing words to match Paul's intense gaze. Loosely translated, we read: "Brethren, you know the season, that it is now the hour for us to wake from sleep" (cf. Rom 13:11).

Notes

1. U.S. Conference of Catholic Bishops, *Built of Living Stones* (Washington, DC: USCCB Publishers, 2001).

2. *The Acts of Paul and Thecla.* Trans. Jeremiah Jones (1693–1724).

3. Michael J. Gorman, *Apostle of the Crucified Lord* (Grand Rapids: William B. Eerdmans, 2004), 44.

4. "Look, I have engraved you on the palms of my hands ..." (Isa 49:16).

5. "I was beside him, delighting him day after day, ever at play in his presence, at play everywhere on his earth, delighting to be with the children of men" (Prov 8:30–31).

6. "Keep me as the apple of your eye ..." (Ps 17:8).

7. This is a term often used by Blessed James Alberione in his preaching and writings when trying to convey the meaning of Paul's cry: "It's Christ who lives in me!" (Gal 2:20). For example, Blessed Alberione stated: "We will not become saints except in the measure in which we live the life of Christ, or better yet, *in the measure in which Christ lives his life in us.* The process of sanctification is a process of christification. The Christian must become another Christ." (From the Bulletin *San Paolo*, June–July 1963, p. 3. www.alberione. org.)

8. Cf. Blessed James Alberione, *Abundantes Divitiae Gratiae Suae*, no. 160. (Hereafter cited as *Abundantes*.)

9. Teresa of Avila, *The Life of Teresa of Jesus; the Autobiography of Teresa of Avila*, trans. E. Allison Peers (New York: Image Books, 2004), 119, 134, 137.

10. N. T. Wright, *Paul for Everyone: Galatians and Thessalonians* (Louisville: Westminster John Knox Press, 2004), 52–53.

11. An exultant cry proclaimed by Blessed James Alberione at the conclusion of the meditation-conference on the Solemnity of St. Paul in 1934.

12. Blessed James Alberione (1884–1971) is the founder of the Daughters of St. Paul and other congregations of the Pauline Family. See Chapter VIII for more information.

13. Refer to Chapter X.

14. Cf. John Paul II, "Letter to the Elderly" (Vatican City, 2006).

15. Juan Alonso Villabrille y Ron. http://museoescultura.mcu.es/coleccion/obras/villabri_en.html.

16. Jacobus de Voragine, *The Golden Legend*, trans. William Caxton, 1483.

17. Cf. Gal 2:20; Phil 3:8; Gal 6:14; Rom 14:8, 2; Tim 3:10–11.

18. *Abundantes*, no. 198.

19. For further information on the congregations and institutes of the Pauline Family, visit www.alberione.org (parts of this Web site are in Italian).

20. *Abundantes*, no. 64.

21. Based on a prayer by Blessed James Alberione.

Bibliography

Apostolos-Cappadona, Diane, ed. *Art, Creativity, and the Sacred*. New York: Continuum, 1998.

Boadt, Lawrence, C.S.P. *The Life of Paul*. New York/ Mahwah, NJ: Paulist Press, 2008.

Brown, Raymond E. *An Introduction to the New Testament*. New York: Doubleday, 1997.

Collins, Raymond E. *The Power of Images in Paul*. Collegeville, MN: Liturgical Press, 2008.

Decaux, Alain. *Paul, Least of the Apostles*. Boston: Pauline Books & Media, 2006.

Dunn, James D.G. *The Theology of Paul the Apostle*. Grand Rapids: William B. Eerdmans, 2006.

Durepos, Joseph. *A Still More Excellent Way*. Chicago: Loyola Press, 2008.

Gorman, Michael J. *Apostle of the Crucified Lord*. Grand Rapids: William B. Eerdmans, 2004.

Harrington, Daniel J., S.J. *Meeting Paul Today*. Chicago: Loyola Press, 2008.

Martini, Carlo Maria, S.J. *Gospel According to Saint Paul*. Trans. Marsha Daigle-Williamson. Ijamsville, MD: Word Among Us Press, 2007.

———. *The Testimony of St. Paul*. Trans. Susan Leslie. Slough, UK: St. Paul Publications, 1983.

Murphy-O'Connor, Jerome. *Paul the Letter-Writer*. Collegeville, MN: Liturgical Press, 1995.

———. *Jesus & Paul, Parallel Lives.* Collegeville, MN: Liturgical Press, 2007.

———. *Paul, A Critical Life.* New York: Oxford University Press, 1998.

———. *Paul, His Story.* New York: Oxford University Press, 2006.

Ryken, Leland, James C. Wilhoit, and Tremper Longman III, eds. *Dictionary of Biblical Imagery.* Downers Grove, IL: InterVarsity Press, 1998.

St. Paul Catholic Edition: New Testament. Trans. Mark Wauck. Boston: Pauline Books & Media, 2000.

Society of St. Paul. *Il Tempio San Paolo: Storia e Art.* Alba, Italy: Edizioni Paoline, 1988.

Teresa of Avila. *The Life of Teresa of Jesus; the Autobiography of Teresa of Avila.* Trans. E. Allison Peers. New York: Image Books, 2004.

United States Conference of Catholic Bishops. *Built of Living Stones: Art, Architecture, and Worship.* Washington: USCCB, 2000 http://www.nccbuscc.org/liturgy/livingstonesind.shtml

Viladesau, Richard. *Theology and the Arts.* New York/ Mahwah, NJ: Paulist Press, 2000.

Wauck, Mark, trans. *Letters of St. Paul.* Boston: Pauline Books & Media, 2008.

Witherup, Ronald, S.S. *101 Questions & Answers on Paul.* New York/ Mahwah, NJ: Paulist Press, 2003.

———. *St. Paul, Called to Conversion.* Cincinnati: St. Anthony Messenger Press, 2007.

———. *Stations of the Cross According to Saint Paul.* New York/ Mahwah, NJ: Paulist Press, 2008.

Wright, N.T. *Paul.* Minneapolis: Fortress Press, 2005.

———. *Paul for Everyone: Galatians and Thessalonians.* Louisville: Westminster John Knox Press, 2004.

BOOKS & MEDIA

A mission of the Daughters of St. Paul

As apostles of Jesus Christ, evangelizing today's world:

We are CALLED to holiness
by God's living Word and Eucharist.

We COMMUNICATE the Gospel message
through our lives and through all
available forms of media.

We SERVE the Church
by responding to the hopes and needs
of all people with the Word of God,
in the spirit of St. Paul.

For more information visit our Web site:
www.pauline.org.

Pauline
BOOKS & MEDIA

The Daughters of St. Paul operate book and media centers at the following addresses. Visit, call or write the one nearest you today, or find us on the World Wide Web, www.pauline.org.

CALIFORNIA
3908 Sepulveda Blvd, Culver City, CA 90230 — 310-397-8676
2640 Broadway Street, Redwood City, CA 94063 — 650-369-4230
5945 Balboa Avenue, San Diego, CA 92111 — 858-565-9181

FLORIDA
145 S.W. 107th Avenue, Miami, FL 33174 — 305-559-6715

HAWAII
1143 Bishop Street, Honolulu, HI 96813 — 808-521-2731
Neighbor Islands call: — 866-521-2731

ILLINOIS
172 North Michigan Avenue, Chicago, IL 60601 — 312-346-4228

LOUISIANA
4403 Veterans Memorial Blvd, Metairie, LA 70006 — 504-887-7631

MASSACHUSETTS
885 Providence Hwy, Dedham, MA 02026 — 781-326-5385

MISSOURI
9804 Watson Road, St. Louis, MO 63126 — 314-965-3512

NEW JERSEY
561 U.S. Route 1, Wick Plaza, Edison, NJ 08817 — 732-572-1200

NEW YORK
150 East 52nd Street, New York, NY 10022 — 212-754-1110

PENNSYLVANIA
9171-A Roosevelt Blvd, Philadelphia, PA 19114 — 215-676-9494

SOUTH CAROLINA
243 King Street, Charleston, SC 29401 — 843-577-0175

TEXAS
114 Main Plaza, San Antonio, TX 78205 — 210-224-8101

VIRGINIA
1025 King Street, Alexandria, VA 22314 — 703-549-3806

CANADA
3022 Dufferin Street, Toronto, ON M6B 3T5 — 416-781-9131

¡También somos su fuente para libros, videos y música en español!